TYPOGRAPHY

ROCKPORT PUBLISHERS, INC.
GLOUCESTER, MASSACHUSETTS

First published in the United States of America by:
Rockport Publishers, Inc.
33 Commercial Street
Gloucester, Massachusetts 01930-5089
Telephone: (508) 282-9590
Fax: (508) 283-7141

Distributed to the book trade and art trade
in the United States by:
North Light Books, an imprint of
F&W Publications
1507 Dana Avenue
Cincinnati, Ohio 45207
Telephone: (800) 289-0963

Other Distribution by:
Rockport Publishers, Inc.
Gloucester, Massachusetts 01930-5089

ISBN 1-56496-393-4

10 9 8 7 6 5 4 3 2 1

Layout: Sara Day Graphic Design
Cover Credits: (from left to right, top to bottom) Pages 17, 59, 19, 6, 12, 65, 20

Manufactured in Hong Kong.

Introduction

The advent of the digital age has had an enormous impact on the role of typography in today's graphic design. Advances in software have made thousands of typefaces available to every designer. Typography is more alive than ever—no longer are designers restricted to the "safe" typefaces. The lack of restrictions could have had a detrimental effect, and designers could have lost a sense of the real purpose of the type: simply to be read. Instead, designers have taken type to a new level and created an element that functions not just as text, but as an illustrative element.

Still, the type must serve its purpose. It must compete with the design and win; it must attract the attention of the reader and then hold it with an easy level of readability. The type featured in this book has met these requirements and therefore is successful.

Featuring an enormous number of typefaces, this collection presents type in a variety of places: bags, boxes, letters, posters, brochures, T-shirts, and more. The designers have used old and new typefaces, in the standard Roman style or fancy italic. The same typeface in a different environment can have a vastly different effect, and this book includes all those ways. Use this book for inspiration, see the results others designers' work has produced. Push your creativity to the limit!

Design Firm
Matsumoto Incorporated
All Design
Takaaki Matsumoto
Client
David A. Hanks & Associates/
Montreal Museum of Decorative Arts
Purpose
Exhibition announcement

Image was printed using four match colors.

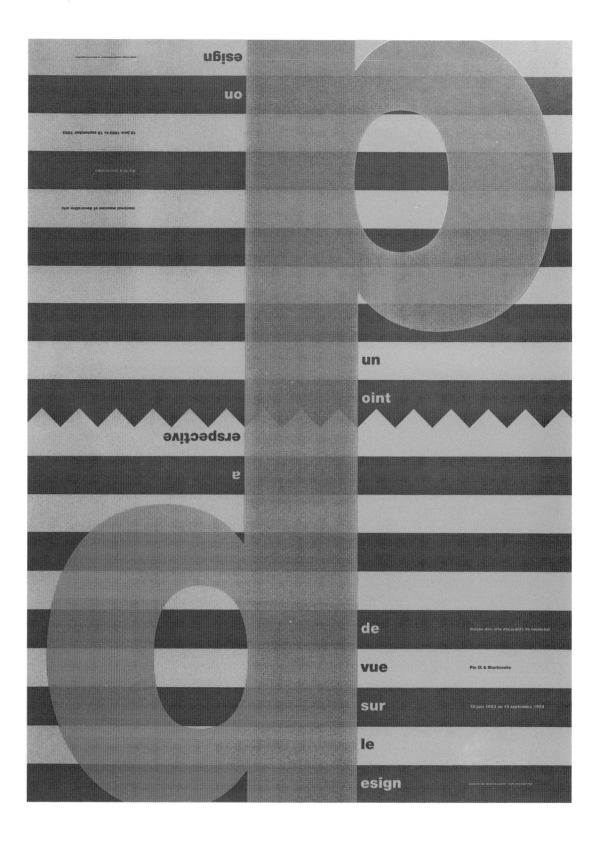

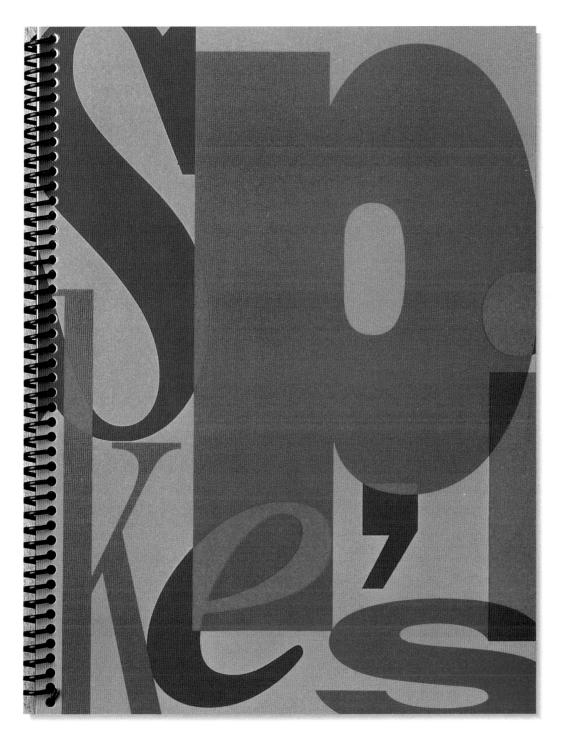

Restaurant
Spike's Jazz Bar
Client
Hotel Principe Felipe
Design Firm
David Carter Design
Art Director
Lori Wilson
Designers
Lori Wilson, Gary Lobue, Jr.
Paper/Printing
Confetti; dull film lamination
on front cover

Adobe Illustrator and Photoshop
were utilized for the front
cover artwork.

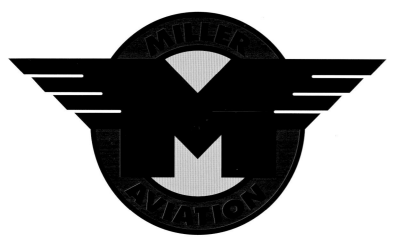

Design Firm
Swieter Design U.S.
Art Director
John Swieter
Designer
Mark Ford
Client
Miller Aviation
Tool
Adobe Illustrator

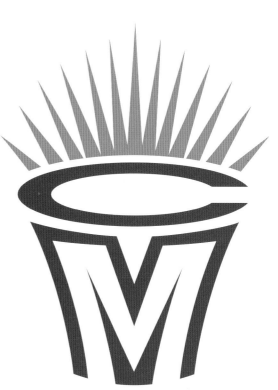

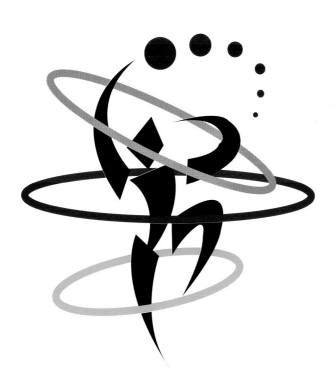

Design Firm
Swieter Design U.S.
Art Director
John Swieter
Designer
Julie Poth
Client
Dallas Mavericks
Tool
Adobe Illustrator

Design Firm
Swieter Design U.S.
Art Director
John Swieter
Designer
Mark Ford
Client
Sports Lab Inc.
Tool
Adobe Illustrator

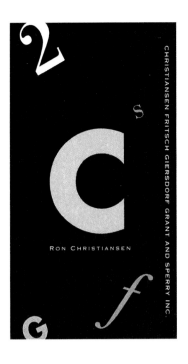

RON CHRISTIANSEN

CHRISTIANSEN FRITSCH GIERSDORF GRANT AND SPERRY INC.

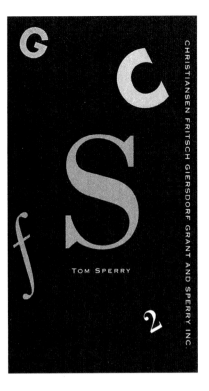

TOM SPERRY

CHRISTIANSEN FRITSCH GIERSDORF GRANT AND SPERRY INC.

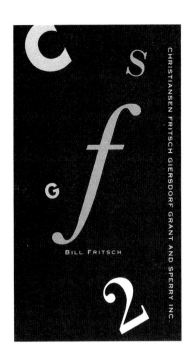

BILL FRITSCH

CHRISTIANSEN FRITSCH GIERSDORF GRANT AND SPERRY INC.

MARKETING

COMMUNICATIONS

TOM SPERRY

1008
WESTERN AVE
SUITE 201
SEATTLE, WA
98104

206 223-6464
FAX 223-2765

Design Firm
Hornall Anderson Design Works
Art Director
Jack Anderson
Designer
Jack Anderson, David Bates
Client
Cf2GS
Marketing communications

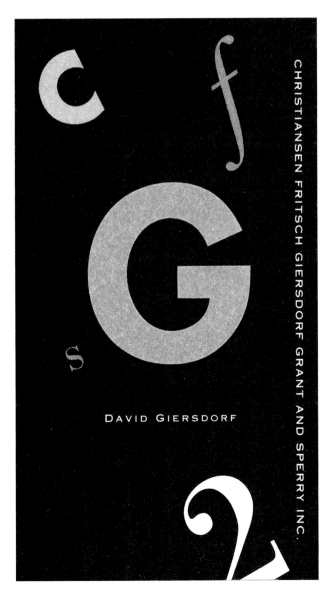

DAVID GIERSDORF

CHRISTIANSEN FRITSCH GIERSDORF GRANT AND SPERRY INC.

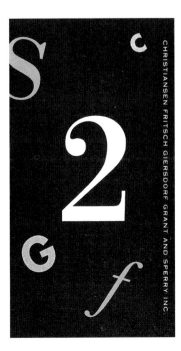

CHRISTIANSEN FRITSCH GIERSDORF GRANT AND SPERRY INC.

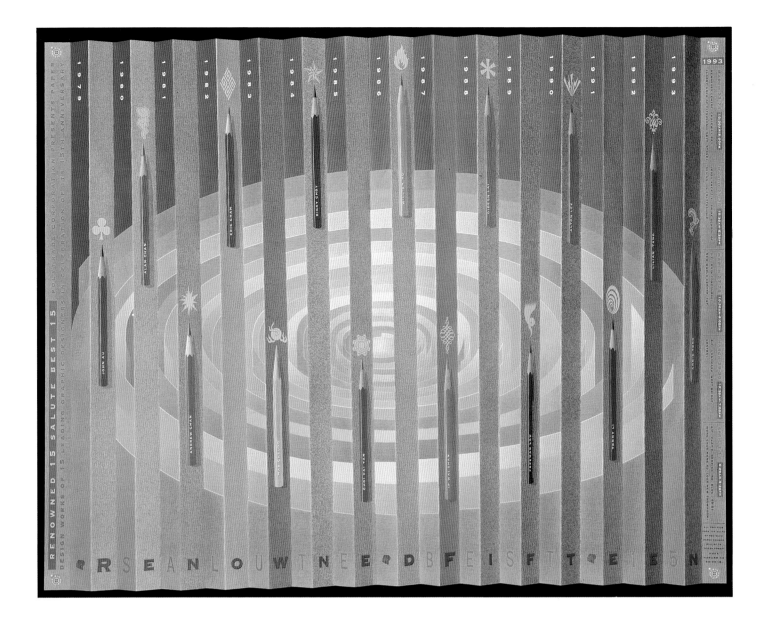

Design Firm
Kan Tai-keung Design & Associates Ltd.
Art Director
Freeman Lau Siu Hong
Designers
Freeman Lau Siu Hong,
Veronica Cheung Lai Sheung
Computer Illustrator
Benson Kwun Tin Yau
Client
Polytrade Corporation
Objective
To produce a poster announcing the 15th anniversary of a paper company

Innovation
A single poster displays three different perspectives. In the right view, 15 pencils represent the 15 designers and their celebratory icons. In the left view, 15 sheets of paper form an unending spiral, representing the client's concept of synergy. From the front, pencils and spiral join to form a 15th-birthday cake for the client.

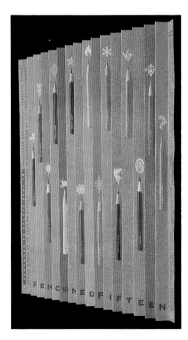

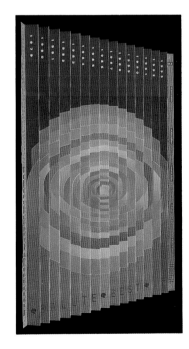

Design Firm
Elmwood
Designer
James Backhurst
Original Size
4" × 6" (10 cm × 15 cm)

Elmwood created a range
of postcards for both
self-promotion and as
compliment slips. The images
on the postcards come from
samples of the firm's work.

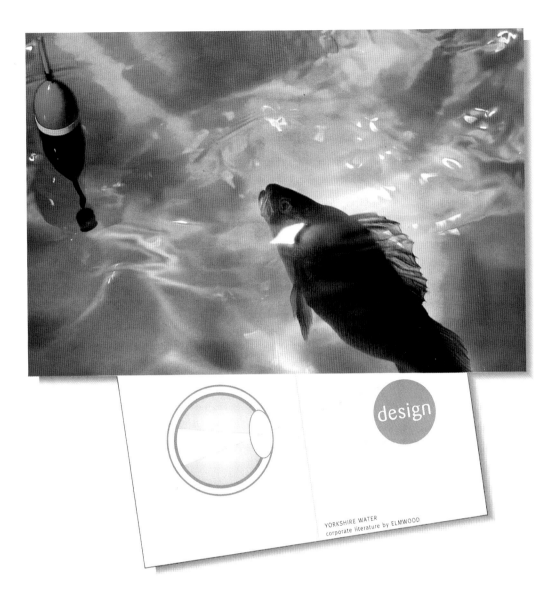

YORKSHIRE WATER
corporate literature by ELMWOOD

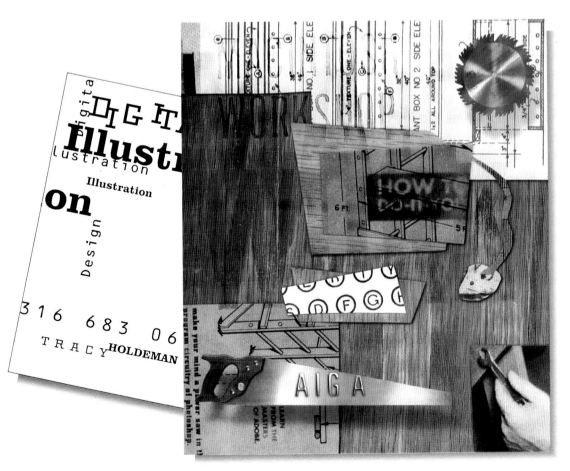

Design Firm
Insight Design Communications
Art Director/Designer/Illustrator
Tracy and Sherrie Holdeman
Original Size
6" × 5" (15 cm × 13 cm)
Client
AIGA, Wichita Chapter
Printing
Indigo press

This piece was the cover of a mailer for
an AIGA/Wichita Macintosh workshop.
It was done entirely in Adobe Photoshop,
depicting a funky computer screen, key-
board, and mouse in a woodsy, "workshop-
like" style. The designer scanned elements
from '50s do-it-yourself books. In the bot-
tom left-hand corner, the designer scanned
type with more pertinent copy.

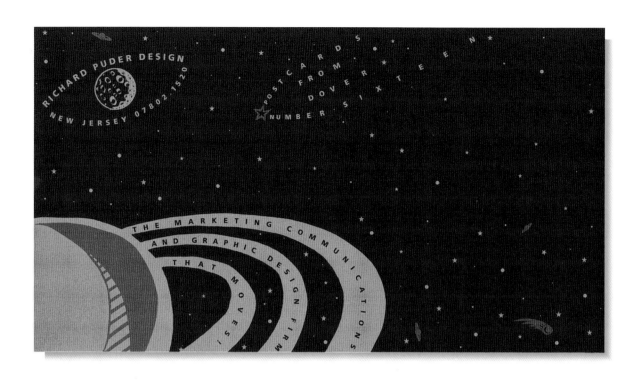

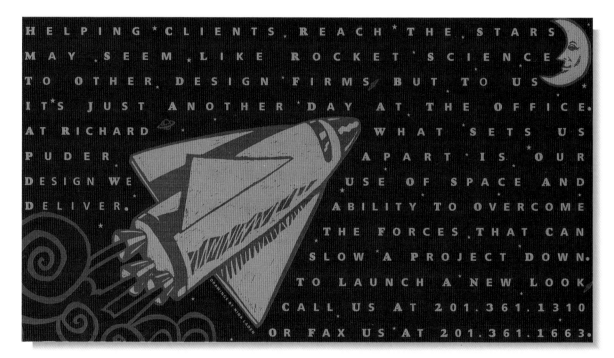

Design Firm
Richard Puder Design
Art Director
Richard Puder
Designer
Lee Grabarczyk
Illustrators
Nina La Den
Original Size
6" x 11" (15 cm x 28 cm)
Printing
2-color; 3-color

Titled "Postcards From Dover No.
16," this series was created in
Macromedia FreeHand, with copy
joined to paths. The series creatively
identifies the firm's location and
underlines what it offers in design.

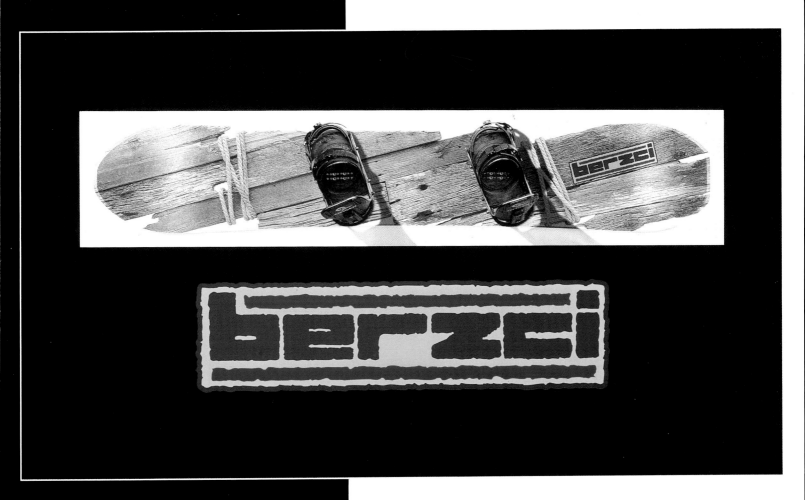

Design Firm
Elton Ward Design & Photography
Designer
Simon Macrae
Art Directors
Simon Macrae, Steve Coleman
Photographer
Andrew Kay
Hardware
Macintosh
Software
Adobe Photoshop, Adobe Illustrator
Client
Elton Ward Design

Four photographic images were combined to create this unique snowboard. An existing snowboard was first photographed to provide a template for shape and form. Driftwood was laid within this shape, tied with rope, and then photographed. Existing shoe fittings were individually photographed. All images were combined together in Photoshop. The edges of the snowboard were further retouched to create a beveled edge, and a highlight effect was added to each end to create an upward curved impression. The logo was developed first by hand, and then rebuilt in Illustrator.

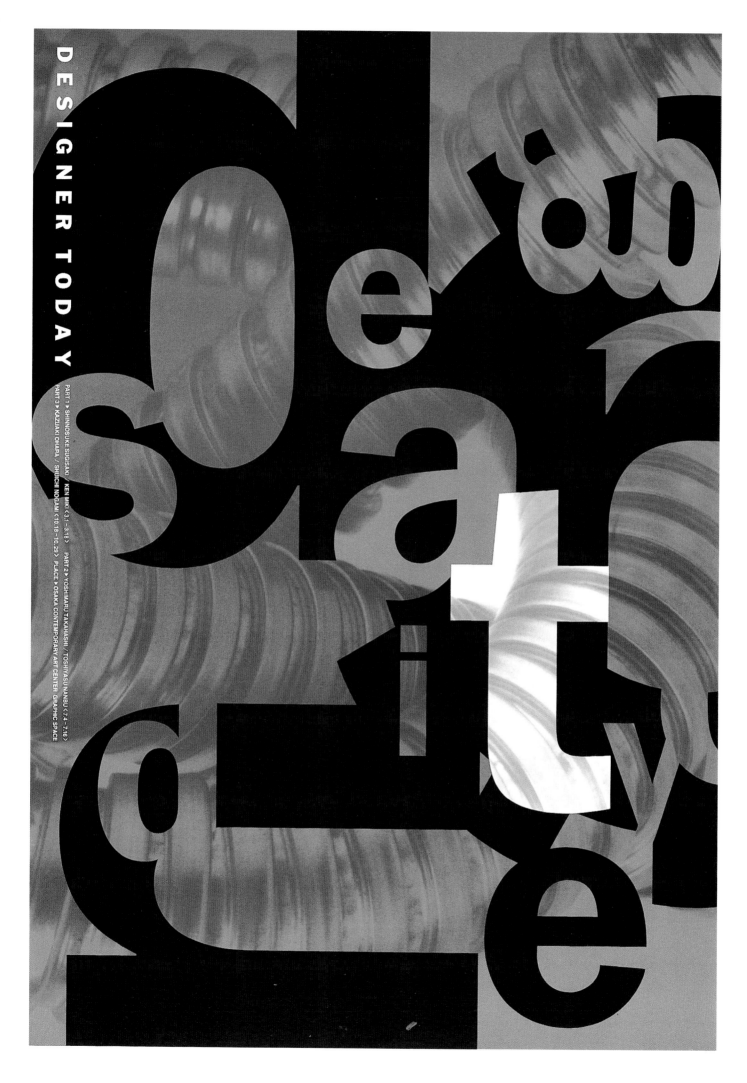

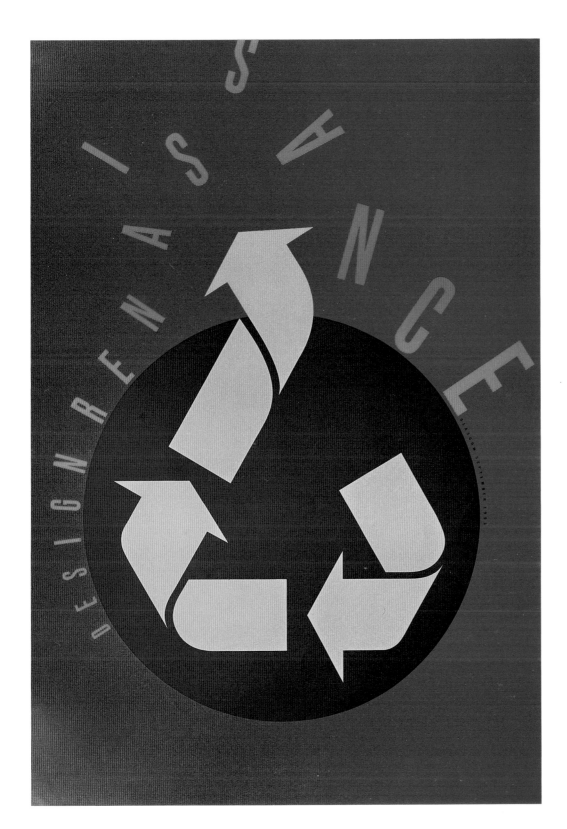

Design Firm
Pentagram Design
Art Director
Woody Pirtle
Designers
Woody Pirtle, John Klotnia
Client
Ico Grada
Purpose
International Design Renaissance
Congress promotion
Size
23" x 33" (58.4cm x 83.8cm)

(facing page)
Design
Shuichi Nogami for Nogami Design Office
Client
Osaka Contemporary Art Center
Tools
Adobe Illustrator, Adobe Photoshop on Macintosh
Font
Franklin Gothic Demi

The letters and the photograph were compounded.

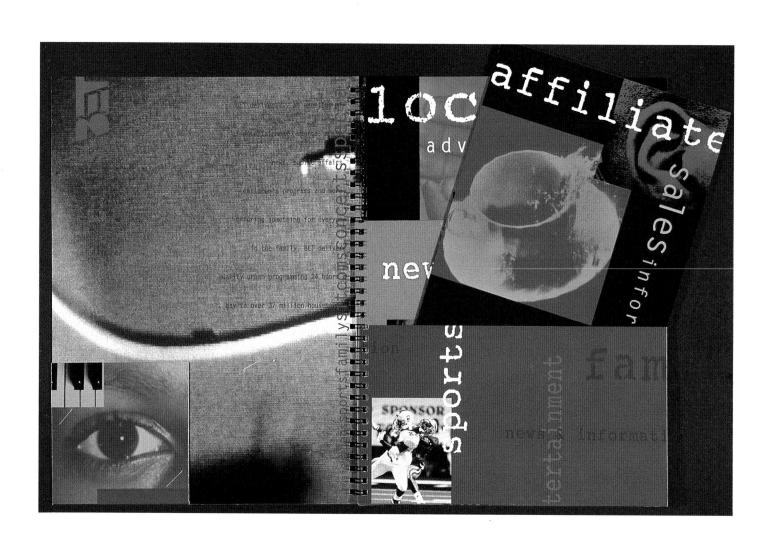

Design Firm
Supon Design Group, Inc.

Art Directors
Supon Phornirunlit, Andrew Dolan

Creative Director
Scott Perkins

Designer
Andrew Berman

Project Directors
LaTanya Butler, Angela Scott, Matilda Ivey

Client
Black Entertainment Television

Objective
To design a sales promotion kit that would project the diversity and excitement of the client's programming

Innovation
Using a folder with a wild array of pockets unmatched in most print pieces, this project sports not only novel type treatment and kinetic graphics, but also odd-sized pockets that include a tiny corner niche that conveniently holds a business card.

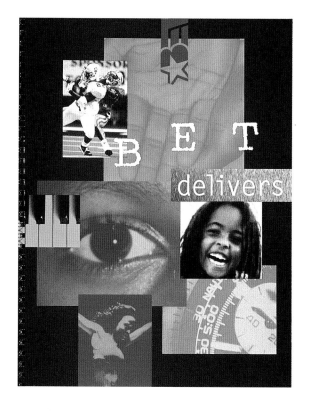

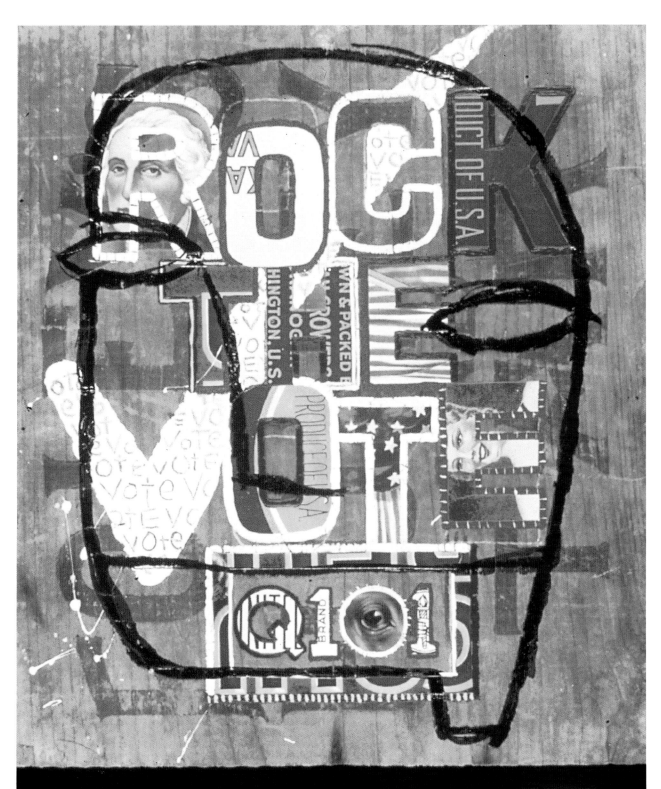

Be the power. Voice your choice AND Rock The Vote!

Design
Laura Alberts for Segura, Inc.
Project
Rock the Vote
Client
Q101
Tools
QuarkXPress, Adobe Illustrator,
Adobe Photoshop
Font
Colonist

Q101 Radio in Chicago is a sponsor for
Rock the Vote.

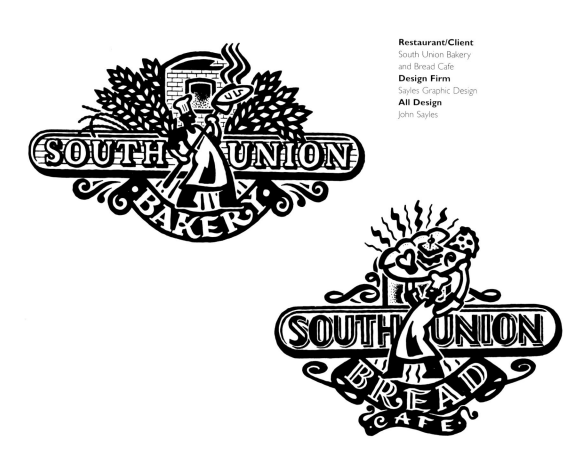

Restaurant/Client
South Union Bakery
and Bread Cafe
Design Firm
Sayles Graphic Design
All Design
John Sayles

Restaurant
Pulp—A Juice Bar
Client
David Sokolow, Philip Cohen
Design Firm
Shelley Danysh Studio
All Design
Shelley Danysh

This project was created with
Adobe Illustrator.

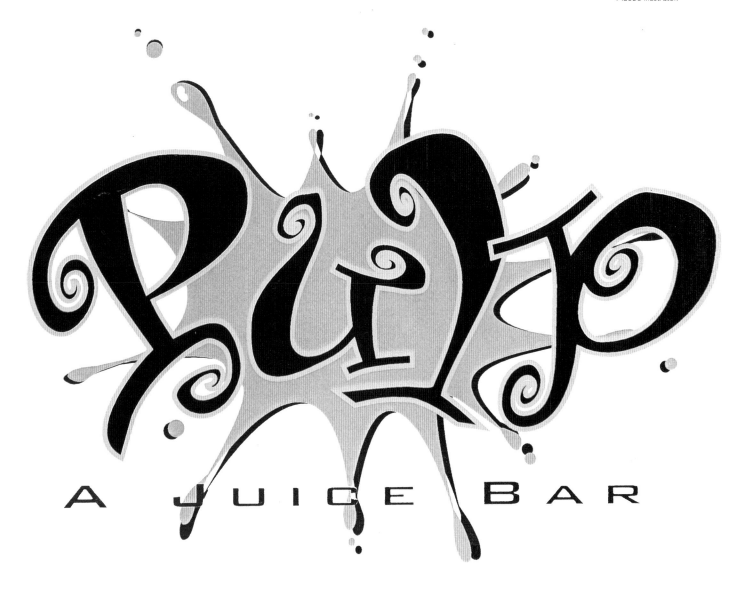

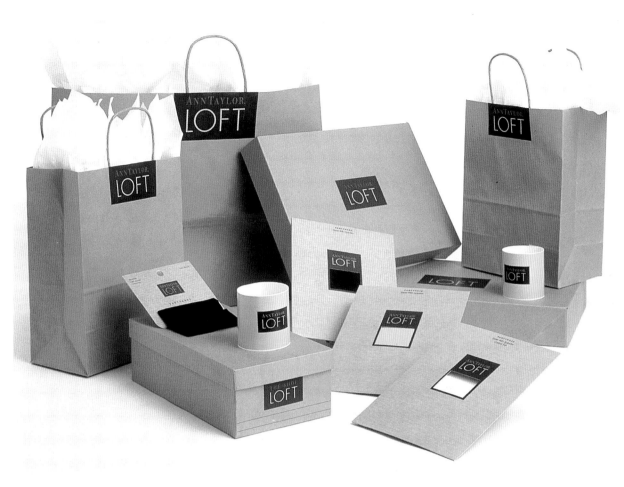

Design Firm
Desgrippes Gobé
and Associates
Art Director
Peter Levine
Designer
Kim Tyska
Photographer
François Halard
Client/Store
Ann Taylor/Loft
Bag Manufacturer
Wright Packaging
Paper/Printing
Recycled kraft paper

This shopping bag is really simple, unpretentious, and almost minimal. It is about the bare essentials. However, it retains Ann Taylor's navy blue color and therefore fits into the total identity of the brand.

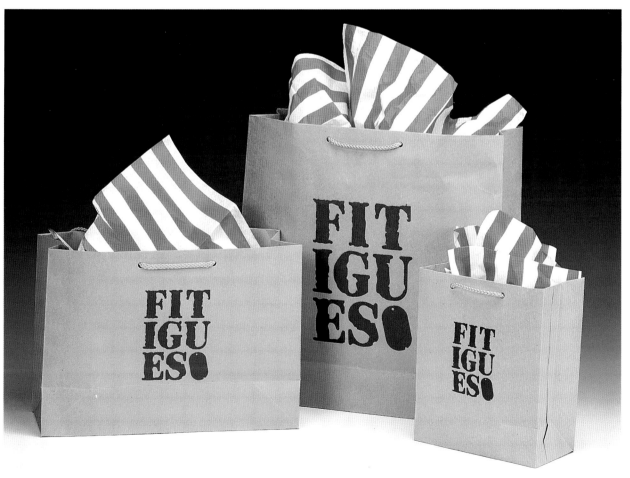

Design Firm
Bob Baittie
Art Director
Catherine Stigler
Designer
Bob Baittie
Client/Store
Fitigues
Bag Manufacturer
Noteworthy
Paper/Printing
Kraft

17

Design Firm
Pentagram Design
Art Director
Paula Scher
Designer
Paula Scher
Client
Ico Grada
Purpose
International Design Renaissance
Congress promotion
Size
23" × 33" (58.4cm × 83.8cm)

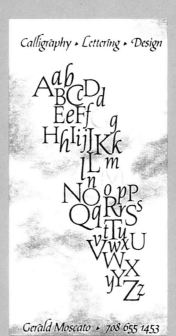

1 Design Firm
Moscato Communications
Designer
Gerald Moscato
Client
Self-promotion
Design and lettering art

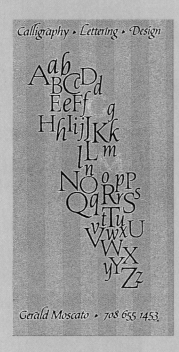

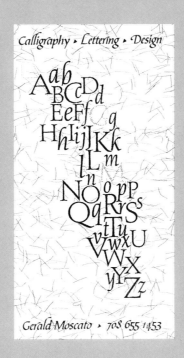

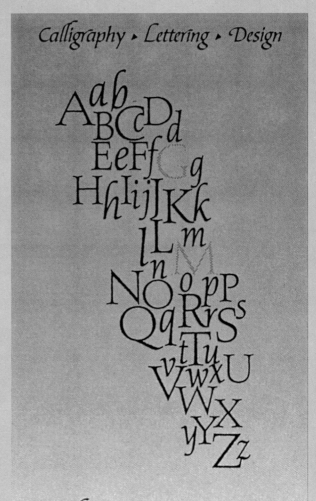

1 Design Firm
Vibeke Nodskov
Designer
Vibeke Nodskov
Client
Groupvision (Nordic)

2 Design Firm
Blue Sky Design
Designer
Maria Dominguez
Client
Nicole Bailey
Design consulting

3 Design Firm
Catalina Communications
Designer
Marji Keim-López
Client
Self-promotion
Environmental graphic design

4 Design Firm
Becker Design
Designer
Neil Becker
Illustrator
Deborah Hernandez
Client
Instinct Art Gallery

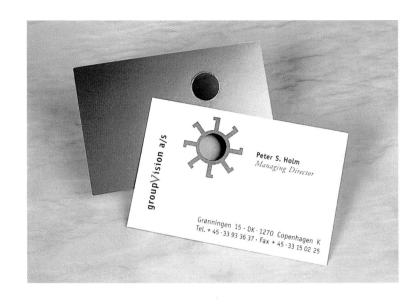

2

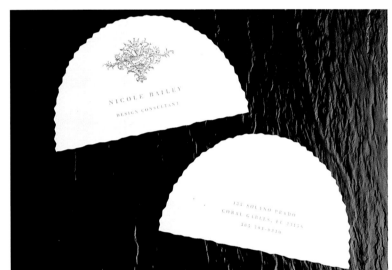

3

4

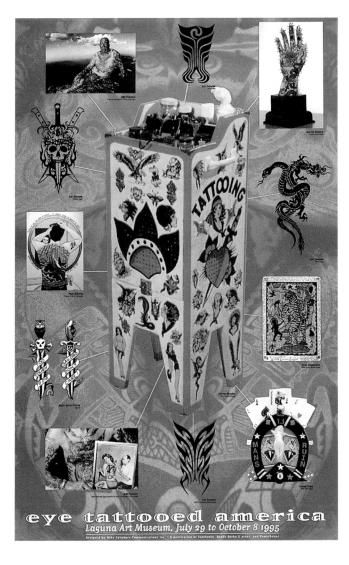

Design
Mike Salisbury, Sander van Baalen, and Sander Egging
for Mike Salisbury Communications, Inc.
Project
Housestyle newsletter
Client
Stat House/Power House
Tools
QuarkXPress, Adobe Illustrator,
Adobe Photoshop on Macintosh
Fonts
Matrix, Wilhelm Klingspor Gotisch

This is the design for the premiere issue of a quarterly
newsletter published by Stat House (a digital and
conventional service bureau) featuring Los Angeles
design and art events. The designers chose the type
to reflect the theme of this issue: tattoo art.

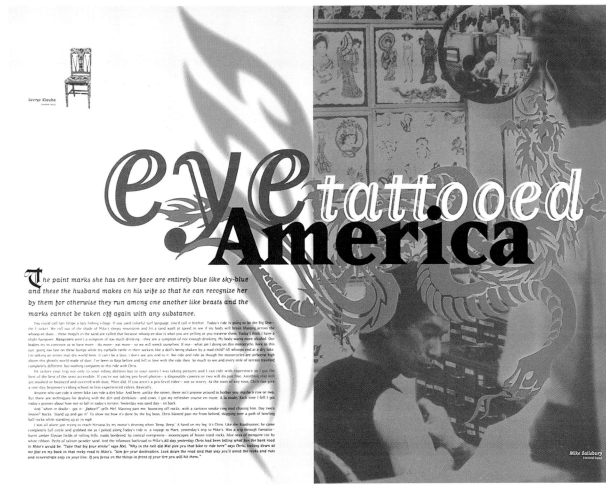

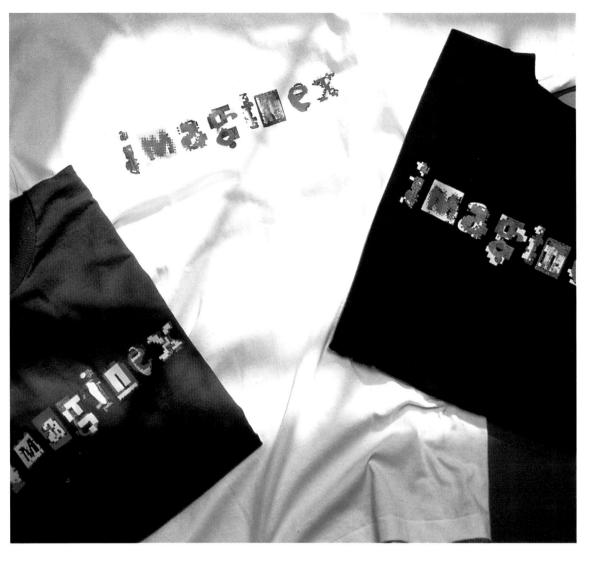

Design Firm
Eskind Waddell
Art Director
Malcolm Waddell
Designer
Nicola Lyon, Florence Ngan,
Gary Mansbridge, Malcolm Waddell
Client
Imaginex Inc.
Purpose or Occasion
Promotion
Number of Colors
Three

Each character of the logo consists of three layers from eight specially designed digital typefaces scanned from a variety of sources. The graphic variations were arrived at very quickly using QuarkXPress and Adobe Photoshop and Illustrator programs. Type images were downsized to a low number of pixel dots per inch and various filters, auto tracers, and screen values were applied. The result is a multiplicity of logos that can be varied and updated for reproduction in one or many colors.

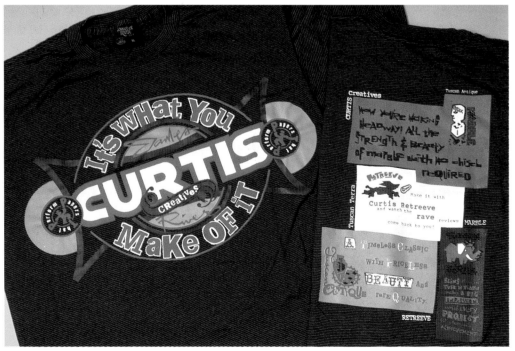

Design Firm
Sayles Graphic Design
All Design
John Sayles
Client
James River Paper Corporation
Purpose or Occasion
Promotion/Introduction
Number of Colors
Three

This T-shirt is one in a series to promote the Curtis Creatives line of fine papers. A series of shirts displays the entire line. "It's What You Make of It" is the theme here.

Restaurant
Cathay Pacific Inflight
Client
Cathay Pacific Airways
Design Firm
PPA Design Limited
Art Director
Byron Jacobs
Designers
Byron Jacobs, Bernard Cau
Paper/Printing
Recycled paper,
offset and letterpress

Australian Aboriginal
cave paintings were used
as visual thread.

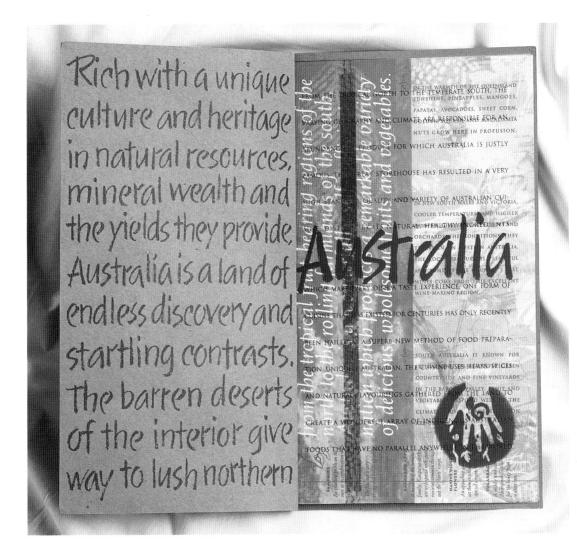

Rich with a unique culture and heritage in natural resources, mineral wealth and the yields they provide, Australia is a land of endless discovery and startling contrasts. The barren deserts of the interior give way to lush northern

Australia

CUISINE FROM THE LAND DOWN UNDER

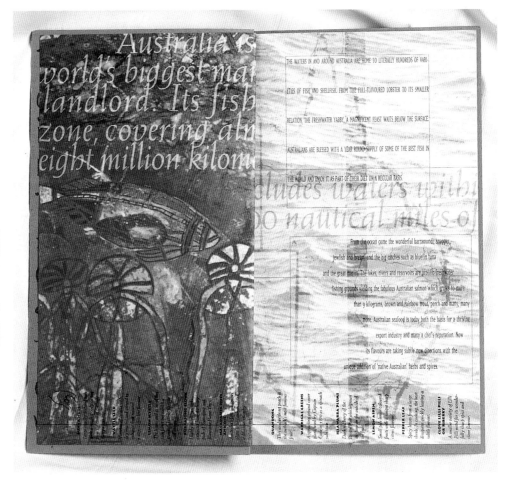

Australia is world's biggest landlord. Its fish zone, covering almost eight million kilomet

23

Design Firm
Leslie Chan Design Co., Ltd.
All Design
Chan Wing Kei, Leslie
Photographer
Outstanding Studio
Client
Taiwan Image Poster
Design Association
Purpose
Self-promotion
Size
23" x 33.5" (60cm x 85cm)

Design Firm
Leslie Chan Design Co., Ltd.
All Design
Chan Wing Kei, Leslie
Photographer
Yu Jung Chin
Client
Poster Design Association
Purpose
Political awareness
Size
23" x 33.5" (60cm x 85cm)

1

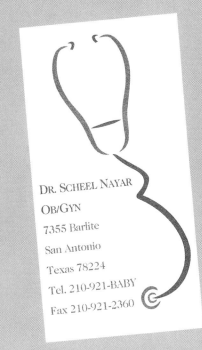

DR. SCHEEL NAYAR

OB/GYN

7355 Barlite

San Antonio

Texas 78224

Tel. 210-921-BABY

Fax 210-921-2360

2

KAMEHACHI
Japanese Restaurant & Sushi Bar

亀
八

1400 North Wells
Chicago, IL 60610
312.664.3663

3

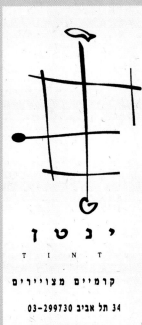

י נ ט ן

T I N T

קרמיים מצויירים

34 תל אביב 03-299730

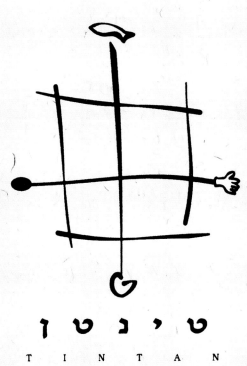

ט י נ ט ן

T I N T A N

אריחים קרמיים מצויירים

שינקין 34 תל אביב 03-299730

4

Dori
Residential & Commercial Cleaning
Voice Mail
&
234-5101

1 **Design Firm**
The Bradford Lawton
Design Group
Art Directors
Brad Lawton,
Jennifer Griffith-Garcia
Designer
Brad Lawton
Illustrator
Brad Lawton
Client
Dr. Scheel Nayar
Obstetrics and gynecology

2 **Design Firm**
Peggy Groves Design
Designer
Peggy Groves
Client
Kamehachi Cafe
Late night Japanese restaurant

3 **Design Firm**
Yaba (Yeh!) Design
Designer
Yael Barnea-Givoni
Client
Self-promotion
Tile design and painting

4 **Design Firm**
GN Design Studio
Designer
Glenda S. Nothnagle
Client
Dori
*Residential and
commercial cleaning*

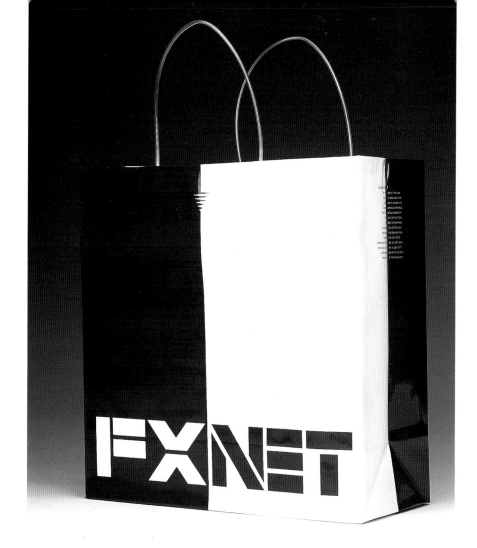

Design Firm
Citicorp Dealing Resource
Art Director
Nancy K. Farlow
Designer
Nancy K. Farlow
Client/Store
Citicorp
Bag Manufacturer
North American
Packaging Corp.
Paper/Printing
White coated, gloss
lamination

This bag employs medical
vinyl tubing for handles; its
design capitalizes on the
two dimensional aspect
of the bag.

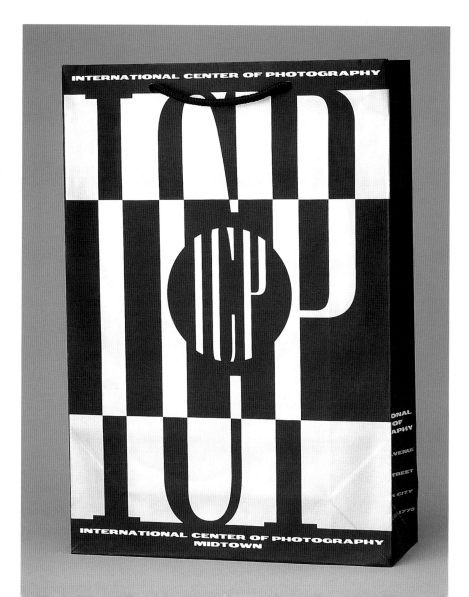

Design Firm
Reliable Design
Art Director
Bill Kobasz
Designer
Bill Kobasz
Client/Store
International Center
of Photography
Bag Manufacturer
North American
Packaging Corp.
Paper/Printing
White coated, matte
laminate

Clever use of metallic ink
and black conveys a silver
photographic element.

ETC
ESPECTÁCULO & CULTURA

LEVA-ME CONTIGO

Design Firm
Mário Aurélio & Associates
Art Director
Mário Aurélio
Designers
Mário Aurélio, Rosa Maia
Original Size
6" × 4" (15 cm × 10 cm)
Client
Cinema Novo, CRL
Printing
2-color offset

Produced in Macromedia FreeHand, this was a promotional mailing touting a newspaper of culture and show business.

Design Firm
Franek Design Associates Inc.
Art Director
David Franek
Designer
Max McNeil
Illustrators
Max McNeil, David Franek
Original Size
3 1/2" × 5" (9 cm × 13 cm);
4" × 6" (10 cm × 15 cm)
Client
Production Club of Greater Washington
Purpose/Occasion
Calendar of events
Printing
Three PMS colors on two sides

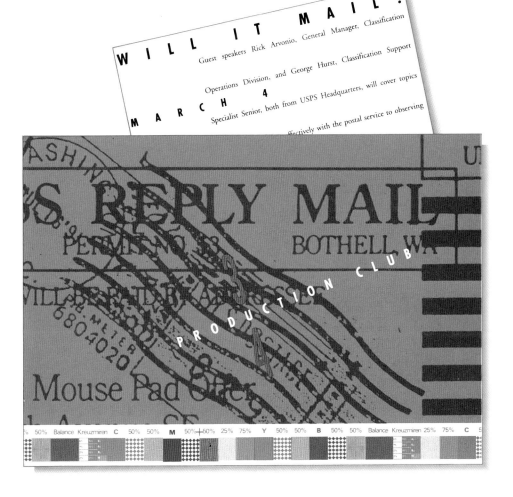

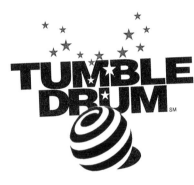

GRENE
C O R N E A

CORNEA · CATARACT &
REFRACTIVE EYE SURGERY

MARK WELLEMEYER, M.D.

8020 East Central
Wichita, KS 67206
Tel 316-636-2010
Fax 316-636-5174
1-800-788-3060

Keller Groves, Inc.

Herman J. Keller
P R E S I D E N T

P.O. BOX 2468
W A U C H U L A
FLORIDA, 33873
813.773.9411

TUMBLE DRUM℠

JACQUELINE SWARTZ

Mid-Rivers Plaza
5849 Suemandy Drive
St. Peters, Missouri 63376
Tel 314-397-7700

Donna Hall

Consultant

104 Randi Drive

Madison, CT 06443

tel 20

fax 20

DONNA HALL

1 Design Firm
Greteman Group
Designers
Sonia Greteman,
Bill Gardner, James Strange
Client
Tumble Drum
Children's recreational center

2 Design Firm
Greteman Group
Designer
Sonia Greteman
Client
Grene Cornea
*Cornea, cataract,
and refractive surgery*

3 Design Firm
JOED Design, Inc.
Designer
Edward Rebek
Client
Herman Keller
Orange grower

4 Design Firm
Greteman Group
Designers
James Strange, Sonia Greteman
Client
Donna Hall
Health care consultant

5 Design Firm
Eat Design
Art Director
Patrice Eilts-Jobe
Designers
Patrice Eilts-Jobe, Kevin Tracy
Illustrator
Kevin Tracy
Client
St. Paul's Episcopal Day School

ST·PAUL'S
EPISCOPAL
DAY SCHOOL

KAREN MONSEES
DIRECTOR OF ADMISSIONS

4041 MAIN STREET
KANSAS CITY, MO 64111
SCHOOL OFFICE 816-931-8614
SCHOOL FAX 816-931-6860

Design Firm
Witherspoon Advertising
All Design
Randy Padorr-Black
Client
Mayfest '97
Purpose or Occasion
Fort Worth's Art and Music festival
Number of Colors
Six

This family event has been around
for more than twenty years. People come
to play games, buy art, listen to music,
watch plays, and take in spring along
the river.

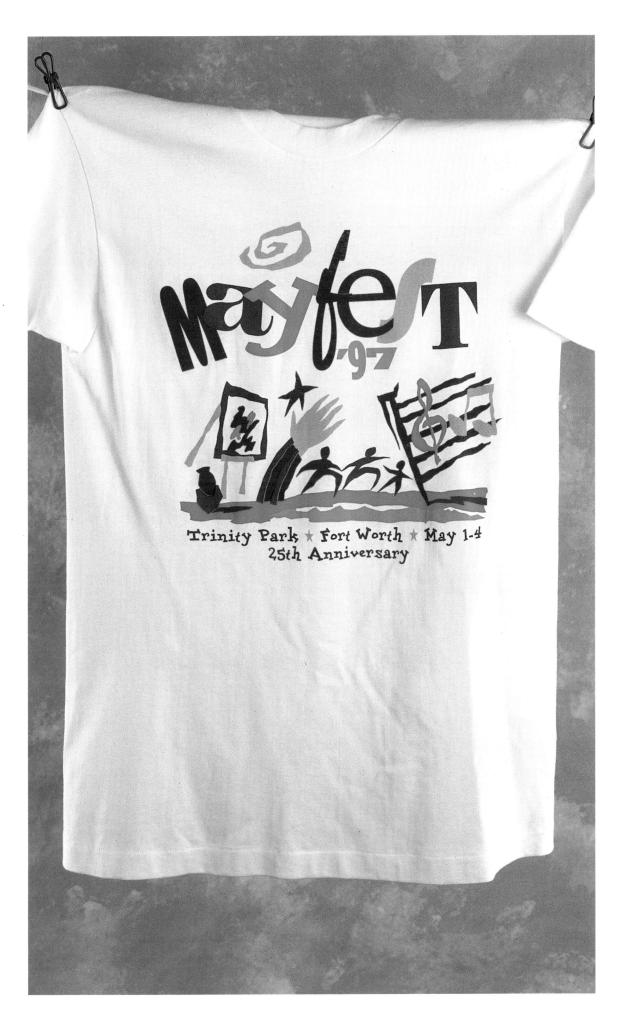

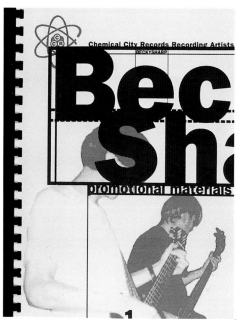

Design Firm
GlueBoy International
Designer
Tal Leming
Project
Becky Sharp Promotional Booklet

The 35mm photos for this band's brochure were developed at a local one-hour photoshop. The photos were scanned in the computer, and halftones and type were output on a laser printer. The booklets were photocopied using black and red toner. Using discarded bindings, band members assembled the booklets.

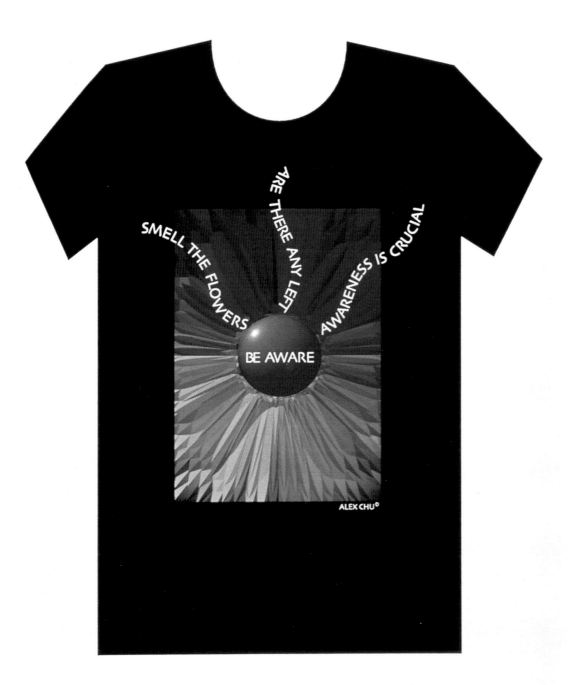

SMELL THE FLOWERS
ARE THERE ANY LEFT
AWARENESS IS CRUCIAL
BE AWARE
ALEX CHU©

All Design
Alex Chu Yew Tien
Purpose or Occasion
Environmental awareness
Number of Colors
Four

The designer intended the strength of the shirt to lie in the visuals in order to catch the viewer's eye.

Jacquelyn McClure

JACQUÉ DESIGN

19353 CARLYSLE STREET
DEARBORN, MI 48124-3802
313.561.6280
FAX 313.561.6920

Jeanne Stevenson

JACQUÉ DESIGN

19353 CARLYSLE STREET
DEARBORN, MI 48124-3802
313.561.6280
FAX 313.561.6920

2

J.C.MUNSON
212 3RD AVE. N
SUITE #385
MPLS, MN 55401
PHONE:612+376+7500
FAX:612+376+0600
STRESS - LAB @
BITSTREAM.MPLS.MN.US

Crystal Folgmann

JACQUÉ DESIGN

19353 CARLYSLE STREET
DEARBORN, MI 48124-3802
313.561.6280
FAX 313.561.6920

1 Design Firm
Jacqué Consulting Inc.
Designer
Crystal Folgman
Client
Self-promotion
Graphic design

2 Design Firm
Stress Lab
Designer
J.C. Munson
Client
Self-promotion
Graphic design

STRESS-LAB
design

CHUCK HERMES
EYES•EARS•NOSE•THROAT
212 THIRD AVE. N., SUITE 385
MINNEAPOLIS
MINNESOTA 55401
TEL.612+376+7500
FAX 612+376+0600
STRESS - LAB@
BITSTREAM.MPLS.MN.US

Art + Design
212 3RD AVE. N. #385
MPLS, MN 55401
PHONE:612-376-7500
FAX:612-376-0600 @
STRESS. - LAB @
BITSTREAM.MPLS.MN.US

STRESS-LAB
Lizz Luce

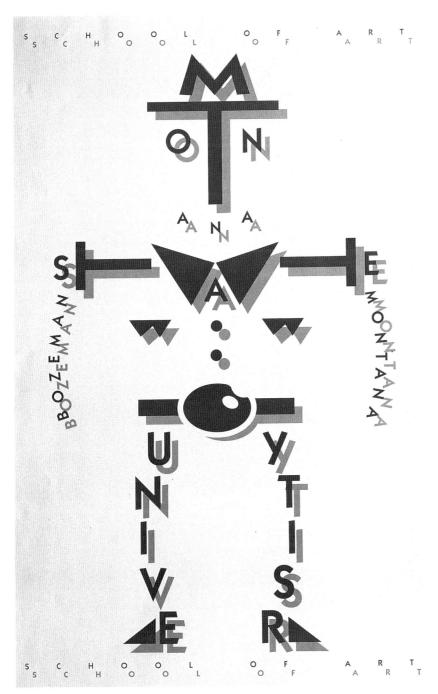

Design Firm
Rickabaugh Graphics
Art Director
Eric Rickabaugh
Designer
Eric Rickabaugh
Illustrators
Eric Rickabaugh,
Michael Smith, Fred Warter
Photographer
Paul Popus
Client
Byrum Litho Graphics
Purpose
Printing promotion
Size
12" x 18" (30.5cm x 45.7cm)

This movie poster was part of an oversized brochure that compared movie making and printing as two very similar crafts.

Design Firm
Planet Design Co.
Art Directors
Dana Lytle, Kevin Wade
Designer
Dana Lytle
Illustrator
Dana Lytle
Photographers
Jodi Hougard, Jayme Schlepp
Client
Montana State University School of Art
Purpose
MSU Art Department promotion
Size
26" x 36" (66cm x 91.4cm)

This design came together with the use of a Macintosh Quadra 700, Aldus FreeHand, and Adobe Photoshop.

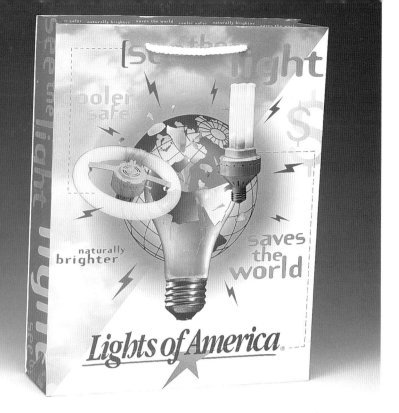

Design Firm
Korito & Associates
Client/Store
Lights of America
Bag Manufacturer
Pacobond Inc.
Paper/Printing
4-color process with gloss
lamination

Design Firm
Pacobond Inc.
Client/Store
Pacobond Inc.–Trade Show
Bag '95
Bag Manufacturer
Pacobond Inc.
Paper/Printing
4-color process with gloss
lamination and holographic
gold foil stamp

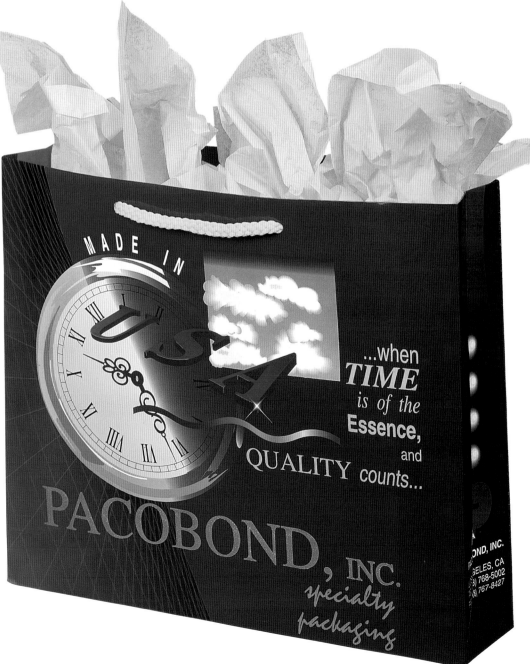

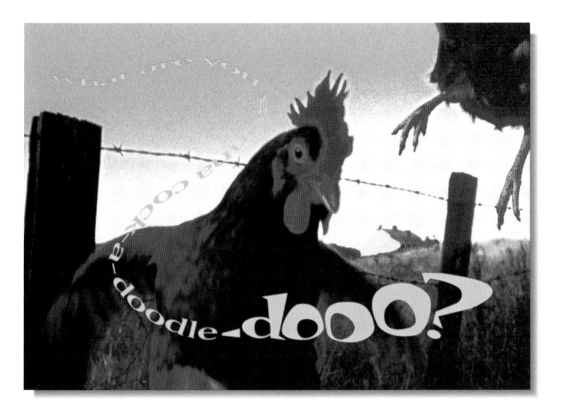

Design Firm
Free-Range Chicken Ranch
Art Director
Toni Parmley
Designer/Illustrator
Kelli Christman
Photographer
Jack Christianson
Original Size
4 1/2" x 6" (11 cm x 15 cm)
Printing
Offset

When an opportunity to get a lot of postcards printed at a discount price came up, this self-promotional card was born. To tie in the chicken theme, the Ranch used real live chickens as models. In processing, the film was damaged; it took 2–3 photos and Adobe Photoshop work to recreate the scene.

Art Director
Dennis Irwin
Designer/Illustrator
Dennis Irwin
Original Size
5" x 7 1/2" (13 cm x 19 cm)

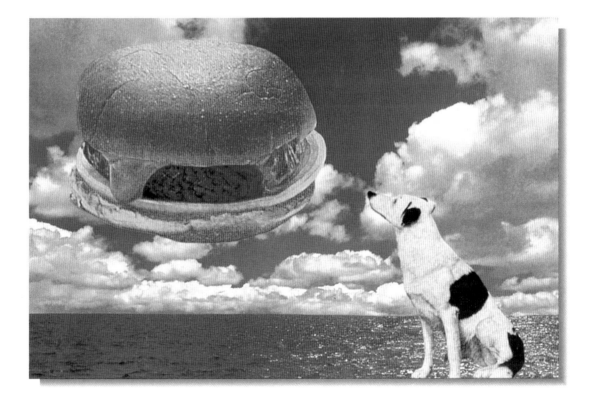

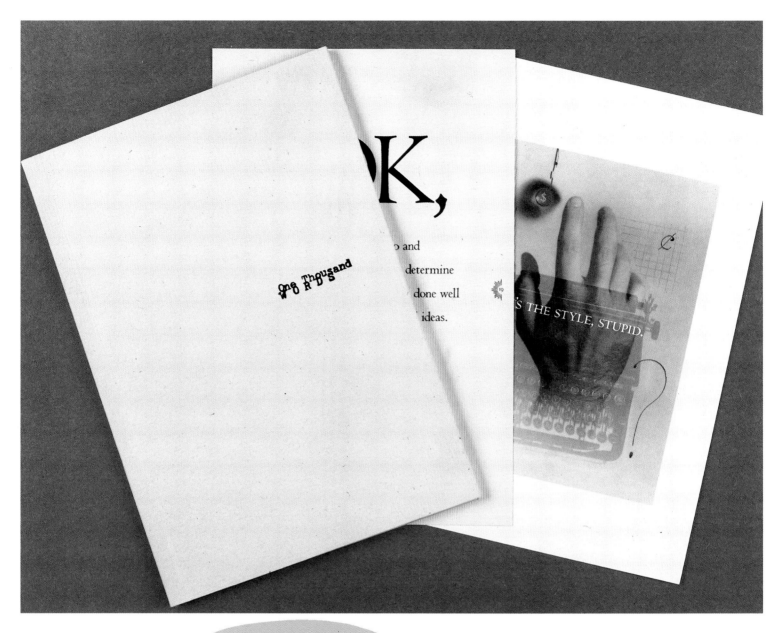

Design Firm
Segura, Inc.
Project
One Thousand Words
All Design
Carlos Segura
Photographer
Geof Kern

This one-color piece was printed in a dark red-brown instead of the traditional black to create a duotone effect for less money.

Design Firm
Kelman Design
Project
Postcards
All Design
Keli Manson

These thank-you notes were created on paper-sample postcards and run through the laser printer. The design was later used as an inexpensive mailing piece, using free samples from a paper company.

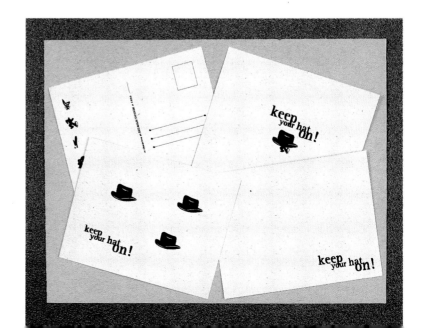

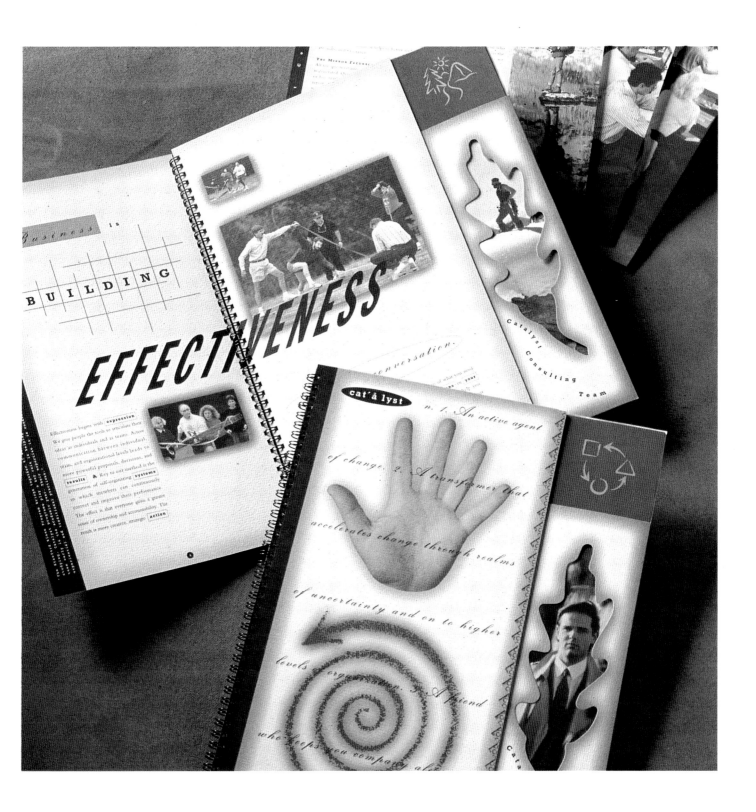

Design Firm
Earl Gee Design
Art Director
Earl Gee
Designers
Earl Gee, Fani Chung
Illustrator
Earl Gee
Photographer
Geoffrey Nelson, Lenny Lind, and associates
Client
Catalyst Consulting Team
Objective
To create a unique capabilities brochure and folder with insert sheets for a management consulting firm specializing in experiential learning

Innovation
The unusual design combines the functionality of a brochure with the flexibility of a pocket folder. The client can customize each brochure for a particular prospect by changing insert sheets to reveal different images through the die-cut leaf.

1

CRISPIN CONSULTING GROUP
1450 MADRUGA AVENUE
SUITE 200
CORAL GABLES, FLORIDA
3 3 1 4 6

CHARLES CRISPIN
305. 669. 9721
FAX
305 669. 9146

1 Design Firm
Pinkhaus Design Corp.
Designer
Susie Lawson
Client
Charles Crispin
Advertising

2 Design Firm
Zauhar Design
Designer
David Zauhar
Client
Scott Gatzke
Photography

3 Design Firm
Design Group Cook
Designer
Ken Cook
Client
Hunter Freeman Photography

4 Design Firm
David Warren Design
Designer
David Warren
Client
Conservation Partners
Land preservation consulting

2

SCOTT GATZKE PHOTOGRAPHY

153 26TH AVE S.E.
SUITE 101
MPLS, MN 55414
TEL: 612·378·0517
FAX: 612·378·9456

3

HUNTER FREEMAN STUDIO

123 South Park

San Francisco

California 94107

Represented by

Bobbi Wendt

 HUNTER FREEMAN

Ph. 415 495 1900

Fax 415 495 2594

4

CONSERVATION

1138 Humboldt Street

Denver, Colorado

80218

(303) 831-9378

FAX (303) 831-9379

P A R T N E R S

MARTY ZELLER
President

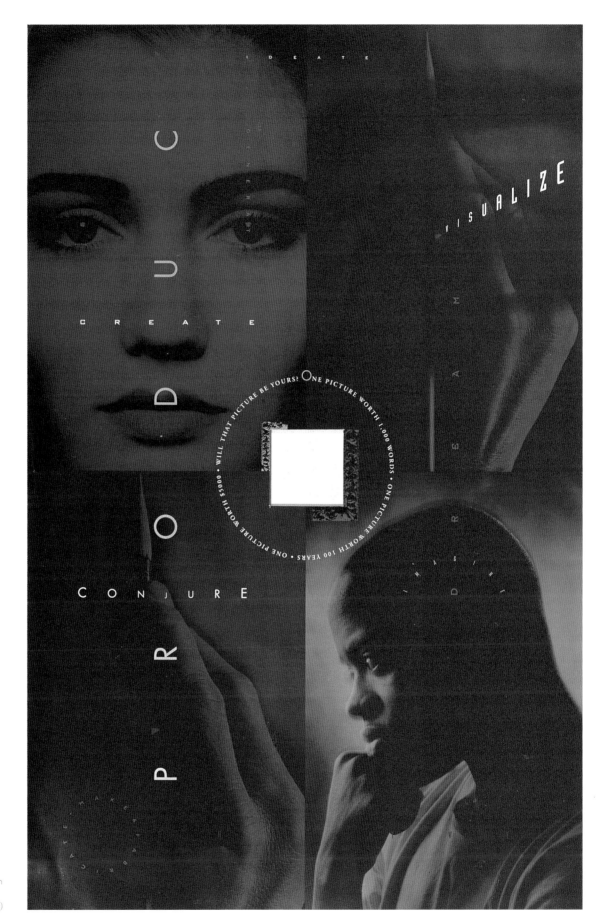

Design Firm
Greteman Group
Art Director
Sonia Greteman
Designers
Sonia Greteman, James Strange
Photographer
Ron Berg
Client
Wichita State University
Purpose
Fine arts competition promotion
Size
13.5" x 21" (34.3 cm x 53.3 cm)

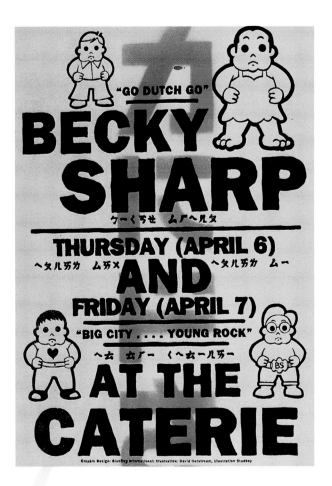

"GO DUTCH GO"

BECKY SHARP

ケーくろせ　ムアへ兄タ

THURSDAY (APRIL 6)

へタ儿労カ　ムヲメ　　AND　　へタ儿労カ　ムー

FRIDAY (APRIL 7)

"BIG CITY YOUNG ROCK"

へ去　去アー　くへ去ー儿労ー

AT THE CATERIE

Graphic Design: GlueBoy International; Illustration: David Hotstream, Illustration Studboy

Design Firm
GlueBoy International
Project
Becky Sharp Poster
Designer
Tal Leming
Illustrator
David Hotstream

The design was done in exchange for free admission to the show. The poster was given a "dirty" letterpress look since it had to be photocopied. The orange characters were spray-painted using a stencil. The top and bottom were then trimmed to give the posters a "print-shop trash" look.

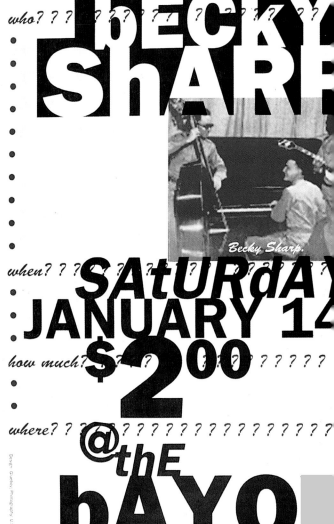

who? ? ? BECKY SHARP ? ? ? ? ? ? ?

Becky Sharp.

when? ? ? SAtURdAY JANUARY 14

how much? $200 ? ? ? ? ?

where? ? ? @thE ? ? ? ? ? ? ? ? ? ? ? ? ? ? ?

bAYOU

Design: Glueboy; Photography: U.S. Army

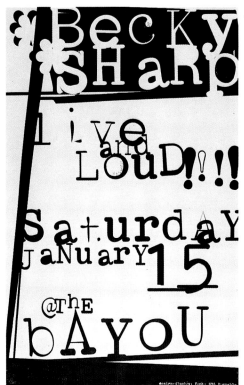

Becky SHaRp

live and LOuD!!!!

SaturdAY
JaNuarY 15
@thE
bAYoU

design: Glueboy; Font: STA Portable

Design Firm
GlueBoy International
Project
Becky Sharp Posters
Designer
Tal Leming
Photographer
U.S. Army

Design for this band promotion was donated in exchange for free admission to shows and an occasional guitar solo on the last song at some shows. The posters were designed to be reproduced on a photocopier using black, blue, and red toner on a variety of colored papers.

Design Firm
Mário Aurélio & Associados
Art Director
Mário Aurélio
Designer
Rosa Maia, Diogo Pecegueiro
Client/Store
Areal Editores
Bag Manufacturer
Material Didáctico
Paper/Printing
2-color

Persuasive bag created for Material Didáctico, which makes toys and games for children.

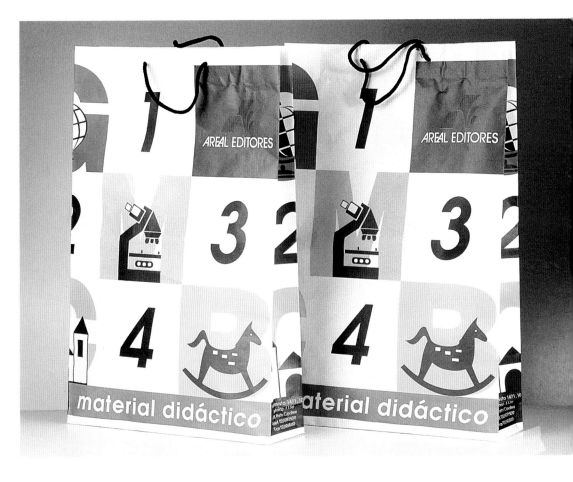

Design Firm
Eric Dewey
Art Director
Harris.Volsic Creative
Designer
Chad Nelson, Dave Volsic
Illustrator
Chad Nelson
Client/Store
North Riverside Park Mall
Bag Manufacturer
Keenpac North America Ltd.
Distributor
Howard Decorative Packaging

This is a one-of-a-kind holiday shopping bag stuffed with hidden coupons. When the coupons are torn off, the bag is still functional. The attached coupons reveal $100 worth of coupons inside. Moreover, one lucky bag owner will find a coupon worth a $1,000 shopping spree.

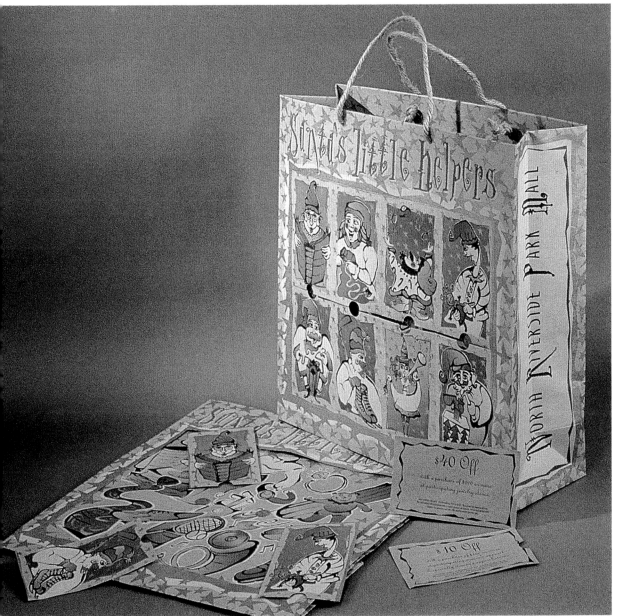

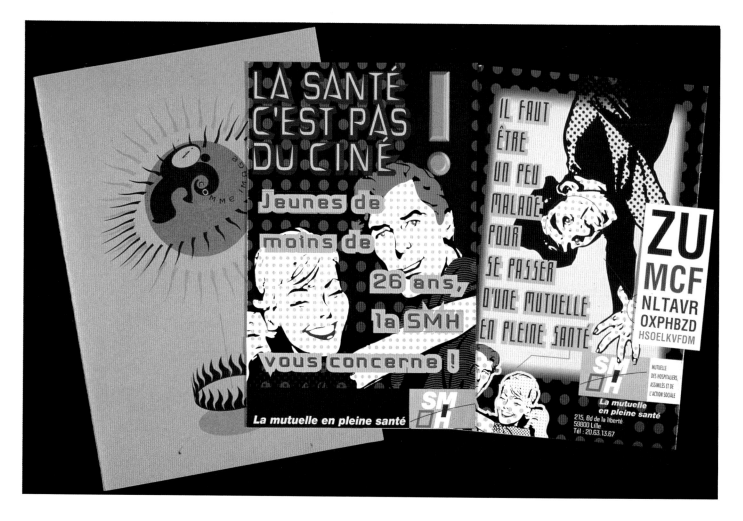

Design Firm
I Comme Image
Art Director
Jean-Jacques Tachdjian
Designer
Jean-Jacques Tachdjian
Computer Illustrator
Jean-Jacques Tachdjian
Client
E.D.P Communication
Objective
To find new prospects under the age of 25 for a hospital mutual
insurance company

Innovation
A lively approach to promoting a service that is often regarded as dull and
uninteresting, this kit uses a combination of illustrations reminiscent of the
1960s work of pop artist Roy Lichtenstein and a typographic layout with spe-
cially designed fonts. The package fuses sedate and comic images to explain
company philosophy and prices to a youthful audience.

BLACK MORGAN
A LABRADOR ✿ ALPHABET

Design Firm
Sea Dog Press
All Design
Leslie Evans
Client
Sea Dog Press
Purpose
Self-promotion
Size
10" × 32.5" (25.4cm × 82.6cm)

The original format of this alphabet was a small accordion book done for a class assignment. When a book publishing deal fell through, the designer printed the alphabet as a poster. Illustrations are pen and ink, and type is taken from proofs of Neuland Foundry type.

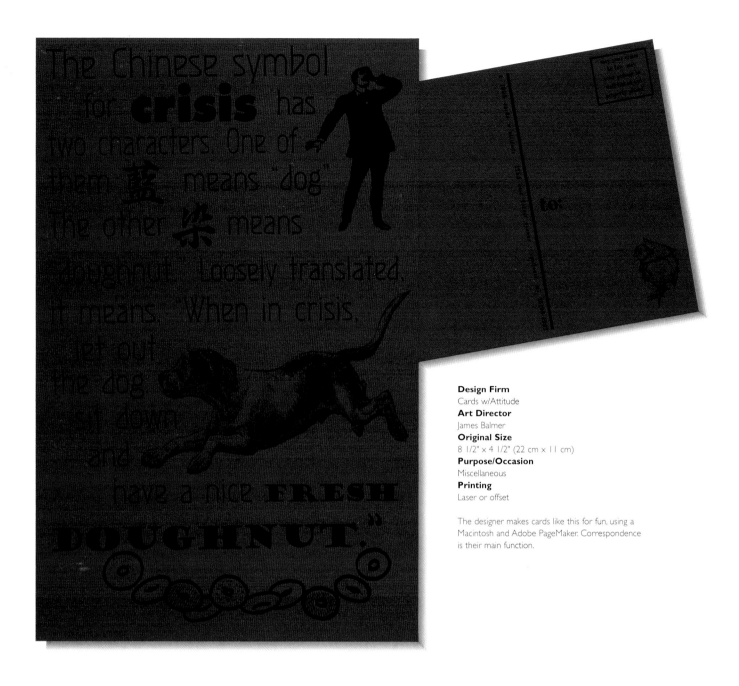

The Chinese symbol for **crisis** has two characters. One of them 藍 means "dog." The other 糕 means "Doughnut." Loosely translated, it means "When in crisis, let out the dog, sit down and have a nice **FRESH DOUGHNUT.**"

Design Firm
Cards w/Attitude
Art Director
James Balmer
Original Size
8 1/2" x 4 1/2" (22 cm x 11 cm)
Purpose/Occasion
Miscellaneous
Printing
Laser or offset

The designer makes cards like this for fun, using a Macintosh and Adobe PageMaker. Correspondence is their main function.

Design Firm
Kan Tai-keung Design
& Associates Ltd.
Art Director
Freeman Lau Siu Hong
Designers
Freeman Lau Siu Hong,
Veronica Cheung Lai Sheung
Original Size
5" x 7" (13 cm x 18 cm)
Client
The Pottery Workshop

Created in Macromedia FreeHand, the logo for The Pottery Workshop portrays a set of pottery works. It symbolizes the various activities and functions carried out by the workshop: pottery courses, shop, exhibitions, and interest groups.

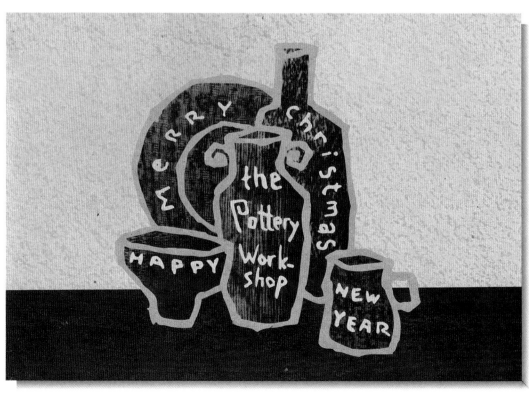

1

eric ruffing

vox 310.546.7135
fax 310.546.6234

3309 pine av
manhattan beach
california
9 0 2 6 6

⑬

ourmindswanderwhereothersfeartogo

2

LA PÊCHE I
GOURMET TO GO & CATERING
1147 BARDSTOWN ROAD
LOUISVILLE, KY 40204
TEL: (502) 451-0377

Michelle Bartholomew

LA PÊCHE II
CAFE & GOURMET TO GO
HOLIDAY MANOR CENTER
4941 BROWNSBORO ROAD
LOUISVILLE, KY 40222
TEL: (502) 339-7593

3

Ruffino Ristorante Italiano
No. 15, Lane 25, Shuang Cheng St., Taipei, Taiwan
Tel: (02) 592-3735
Giurlani Ristorante Italiano
B2 No. 203, Tun Hwa S. Road Sec. 2, Taipei, Taiwan
Tel: (02) 377-0930, 377-0931

意廊意大利套廳
總店 台北市雙城街25巷15號
電話(02)592-3735
遠企店 台北市敦化南路二段203號B2
電話(02)377-0930, 377-0931

4

BODY & SOUL

Mary Mitchell • Therapeutic Massage • 203.535.3039

Nationally Certified • AMTA Member

5

TECHSOURCE
Macintosh Sales & Service

Tom Siechert

5110 E. Clinton Way

Suite 204

Fresno, CA 93727

209 252-8008

fax 252-0664

Design Firm
Hornall Anderson
Design Works Inc.
Art Director
Jack Anderson
Designer
Jack Anderson,
Lisa Cerveny,
Suzanne Haddon
Illustrator
Mits Katayama
Client/Store
Juice Club
Bag Manufacturer
Zenith Paper
Paper/Printing
Kraft; flexo

The pastry and take-out
bags were designed in
Macromedia FreeHand. The
main challenge faced during
printing was keeping the gra-
dation from filling in and
keeping the colors pure
while using only four colors
that graduated from deep
red to green.

Restaurant
Cup•A•Cino Coffee House
Client
Jennifer Bell
Designer
Gloria Paul
Illustrators
Various
Paper/Printing
Wausau Astrobrights
60 lb. text/offset

This project was produced
on a Power Macintosh, using
Macromedia FreeHand.

Design Firm
EMA Design Inc.
Art Director
Thomas C. Ema
Designers
Thomas C. Ema,
Debra Johnson Humphrey
Original Size
10" × 6" (25 cm × 15 cm)
Client
Artist's Angle Inc.
Photographer
Stephen Ramsey
Printing
Offset

These postcards announce
and describe specific services
provided by Artist's Angle. The
designer took the images—
taken by several photogra-
phers—and laid them out in
Macromedia FreeHand.

GENIUS

IS THE CAPACITY TO SEE TEN THINGS

WHERE THE ORDINARY MAN SEES ONE

AND WHERE THE MAN OF TALENT SEES TWO OR THREE

EZRA POUND

ARTIST'S

ANGLE

INC

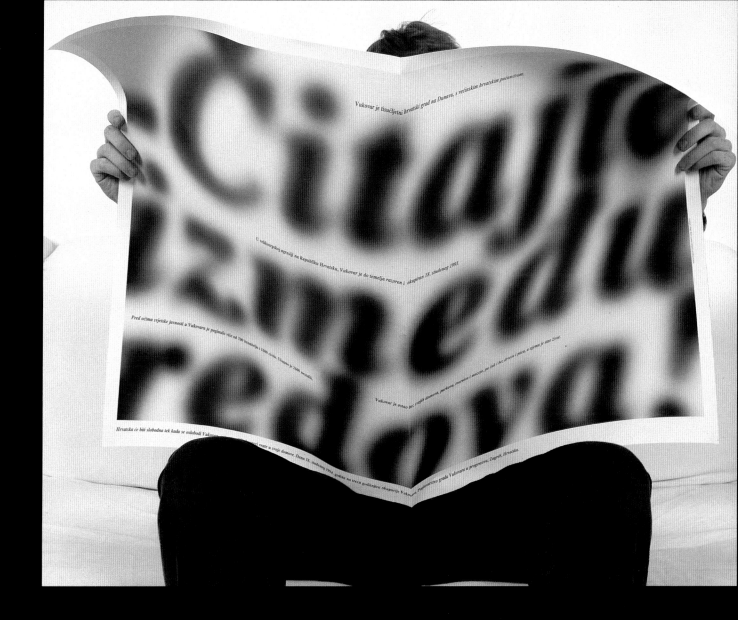

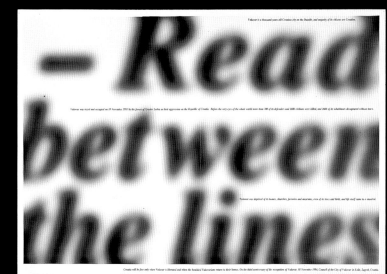

Design Firm
Studio International
Art Director
Boris Ljubičić
Designer
Boris Ljubičić
Illustrator
Boris Ljubičić
Photographer
Damir Fabijanić
Client
Studio International
Objective
To design an informational poster commemorating a highly charged
political event

Innovation
Unique type treatment and use of color produce a highly creative two-sided
poster. With the English version on one side printed in black and cyan and
the Croatian words on the other in black and magenta, the huge type
demands attention while the small type "between the lines" tells the story of
the forced occupation of the town of Vukovar in 1991.

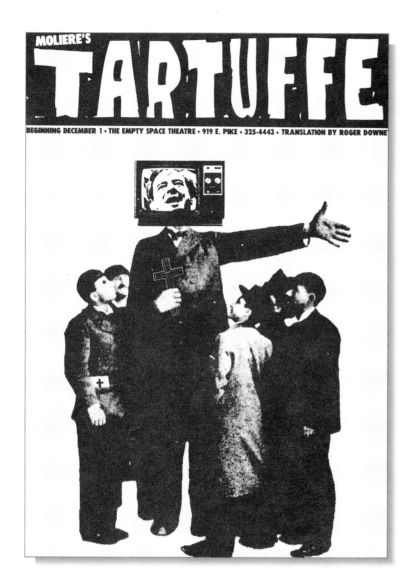

Design Firm
Art Chantry
Art Director/Designer/Illustrator
Art Chantry
Original Size
8 1/2" × 4" (22 cm × 10 cm)
Client
Empty Space Theatre
Printing
Offset

This promotes a production of Molière's 17th-century play *Tartuffe*—a 20th century update of the farcical tale of religious hypocrisy—with Tartuffe as a television evangelist.

Design Firm
Kan Tai-keung Design & Associates Ltd.
Art Director
Freeman Lau Siu Hong
Designer
Pamela Low Pui Hang
Original Size
5" × 7" (13 cm × 18 cm)
Client
Hong Kong Designers Association
Title
"A Tale of Two Squares"

The design of two squares with the exhibitors' names on it was an idea from the coincidence of the two exhibition places: Times Square and Exchange Square.

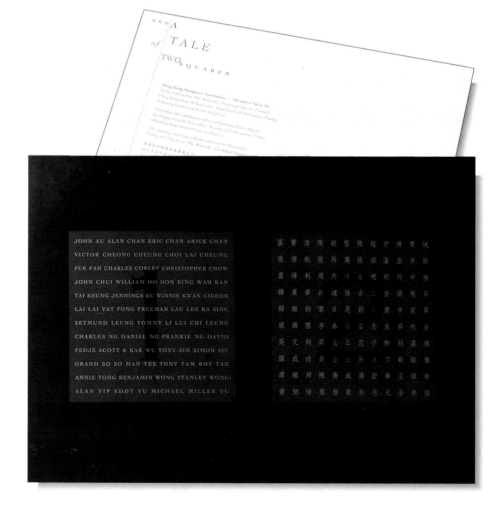

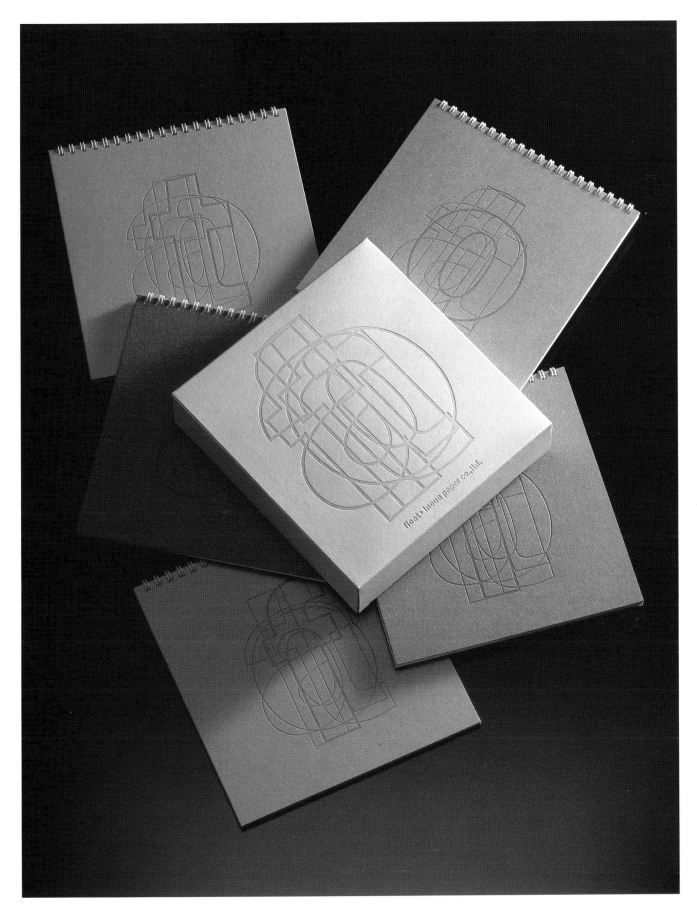

Design
Shuichi Nogami for Nogami Design Office
Client
Inoue Paper Co., Ltd.
Tools
Adobe Illustrator on Macintosh
Fonts
Franklin Gothic Demi

"Float" was printed using a heat treatment
process, and no ink was necessary.

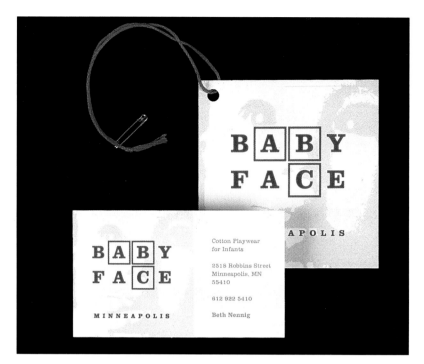

Design Firm
J. Graham Hanson Design
Project
Baby Face Children's Playwear
Designer
J. Graham Hanson
Photographer
Jeremy Clifford

35mm photographs were used in this two-color identity project. Holes were hand-punched in the clothing tags and threaded by hand. This was necessary to launch the initial offering of designs from this small start-up company.

Design Firm
Hornall Anderson Design Works
Project
XactData Stationery and Brochure
Designers
Julie Keenan, Jack Anderson, Lisa Cerveny, Jana Wilson
Art Director
Jack Anderson

Designers consciously left illustrations and photography out of the pieces and did all design work in-house. Pieces were kept to only two colors.

Design Firm
Smith Design Associates
Project
Christ Church Nursery Letterhead
Designer
Eileen Berezni
Art Director
James C. Smith
Illustrator
Eileen Berezni

The design for this letterhead could not include bleeded artwork and could only be one color to save on printing costs. Colored type on colored paper gave the stationery a childlike, fun quality while staying within the budget.

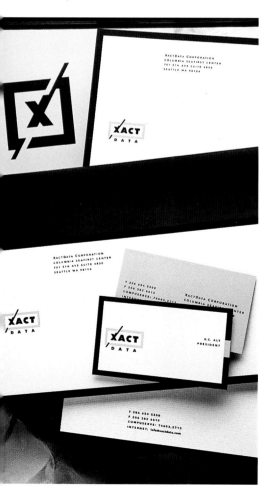

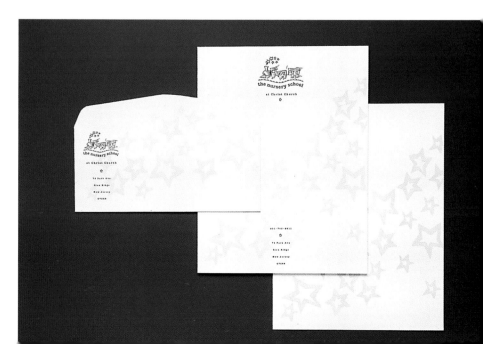

Design Firm
Witherspoon Advertising
All Design
Rishi Seth
Client
Fort Worth Independent
School District
Purpose or Occasion
Children's educational program
Number of Colors
Three

This T-shirt was created for a summer
program that teaches children the
connection between success in school and
success in life. The best way to visually show
this concept was to literally link the initials of
the program's name. The end result was a
shirt with a "cool" graphic presence that
appealed to kids and teachers alike.

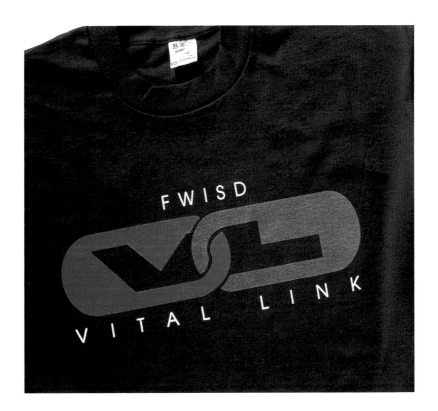

Design Firm
Witherspoon Advertising
All Design
Rishi Seth
Client
Type Case
Purpose or Occasion
Promote Type Case and Fort Worth
Number of Colors
One

This T-shirt was created to promote Type
Case in a fun way. The solution was to
incorporate the affectionate nickname
given to the city ("Cowtown") and make
a humorous play on words using a
type treatment.

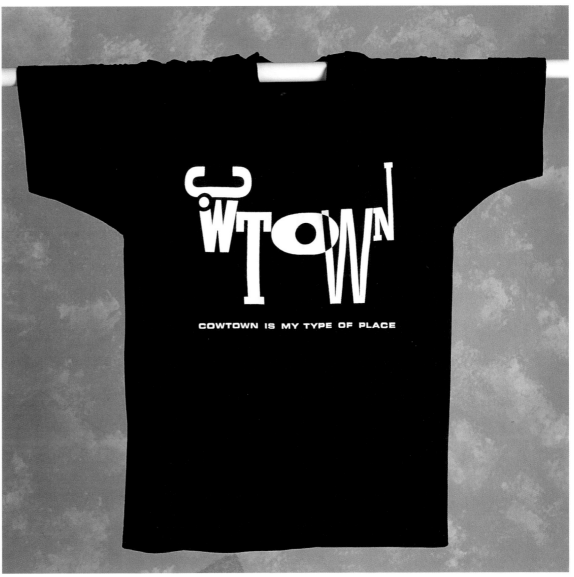

Design Firm
Paper Shrine
Designer
Paul Dean
Client
Vitamin DJ
Disc jockey

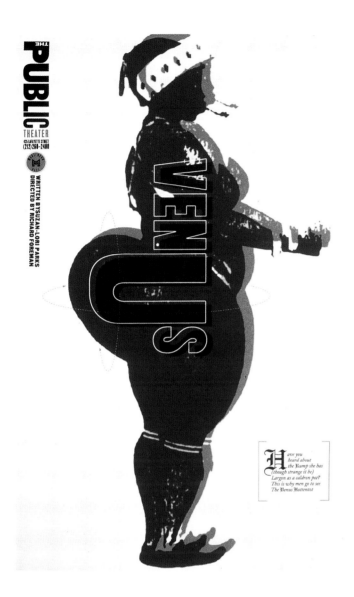

VENUS

Have you heard about the Rump she has (though strange it be) Largon as a caldron pot? This is why men go to see The Venus Hottentot

Design Firm
Pentagram Design
Project
Public Theater poster series
Client
Public Theater
Designers
Ron Louie, Lisa Mazur, and Paula Scher

The varied but cohesive graphic language that Pentagram has developed reflects street typography: It's extremely active, unconventional, and almost graffiti-like.

THE PUBLIC THEATER/NEW YORK SHAKESPEARE FESTIVAL PRESENTS
BRING IN 'DA NOISE BRING IN 'DA FUNK

CALL TELE-CHARGE
IN NY 212-239-6200
NJ/CT OUTSIDE NY METRO AREA 800-432-7250
THE AMBASSADOR THEATRE
219 WEST 49TH STREET
BEGINS APRIL 9TH

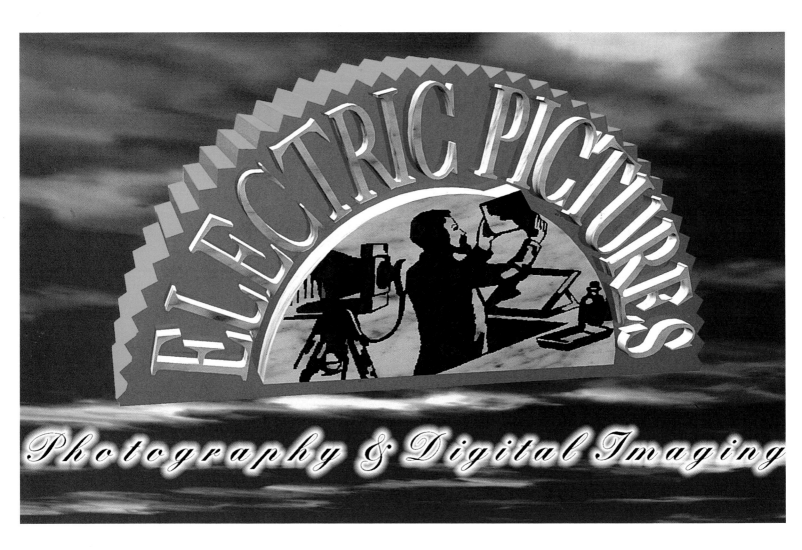

Photographer
John Payne ©1995 Electric Pictures
Hardware
Macintosh IIci with DayStar Turbo 040 accelerator
Software
Ray Dream Designer, Adobe Photoshop, Adobe Illustrator, KPT Bryce
Client
Self-Promotion

The company's name was being changed to Electric Pictures to reflect the
increasing use of computers as well as cameras. Sections of the logo were
imported from Illustrator into Ray Dream Designer where a three-dimensional
image was composed, marble textures were mapped onto the various compo-
nents, and the whole image was then rendered. In Photoshop, the logo was
stripped into a cloudy sky image created in KPT Bryce. The type was imported
from Illustrator into Photoshop.

Design Firm
Tucker Design
Art Director
Barrie Tucker
Designers
Barrie Tucker, Hans Kohla
Finished Art
Hans Kohla
Engraving
Russell Fischer
Client
Woods Bagot
Objective
To design a wine bottle that could be given as a gift to clients and staff on the occasion of the 125th anniversary of Australia's oldest architecture firm

Innovative
The packaging for this gift bottle applies industrial processes to traditional items in an innovative way, similar to the way architects apply them to a building. Using in-depth sandblasting, wax-sealing, and a specially constructed container with corrugated board lining, the packaging draws attention to its dimensionality. Engraving and the color of the bottle form the image of a monumental sculpture made to last for generations.

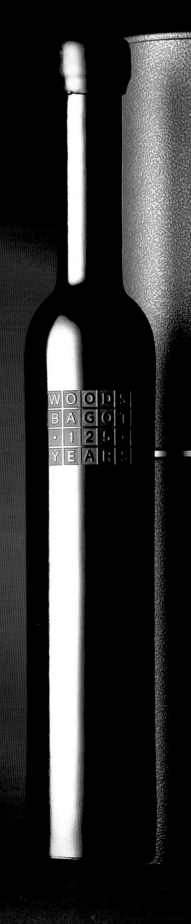

Johnson & Johnson

& johnson

Susan & Wayne are proud to introduce the newest
member in the Johnson family. Maegan Tayler, born on January 11, 1996,
net.wt. 8lbs. 8oz. and length 20.5 inches.

Art Director
Susan Johnson
Designer/Illustrator
Wayne M. Johnson
Original Size
3 1/2" x 5" (9 cm x 13 cm)
Client
Susan & Wayne Johnson
Purpose/Occasion
Birth announcement
Printing
2-color

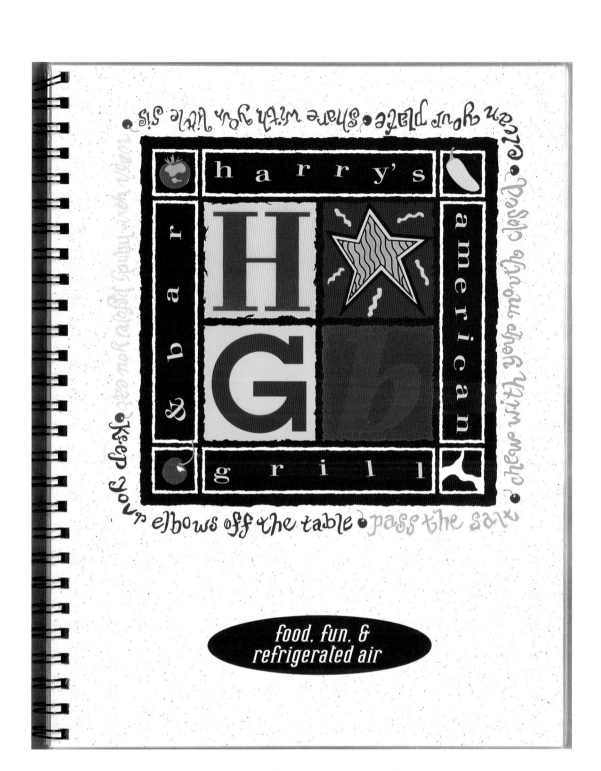

Restaurant
Harry's American Grill & Bar
Design Firm
Val Gene Associates
Art Director/Designer
Lacy Leverett
Illustrator
Morrow Design, Shirley Morrow

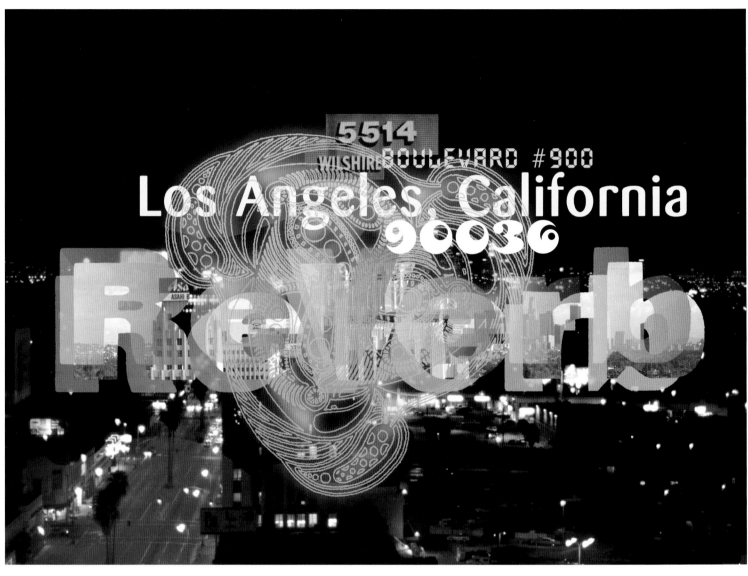

Design
Somi Kim for ReVerb
Project
ReVerb postcard
Tools
Adobe Photoshop, QuarkXPress on Macintosh
Font
Unidentified American wood type, late
nineteenth century

Type from a variety of sources was juxtaposed to
create a multilevel view facing downtown Los
Angeles from the east windows of the studio. The
font (known as Font Doe) was originally hand set
and printed on a letterpress in an unidentified
antique wood font purchased by Harvard's Bow and
Arrow Press from Thomas Todd Printers, Boston.

Restaurant
Waves
Client
Marriott Hotels
Design Firm
Associates Design
Art Director
Chuck Polonsky
Designer
Beth Finn
Illustrator
Kathy Bridgeman

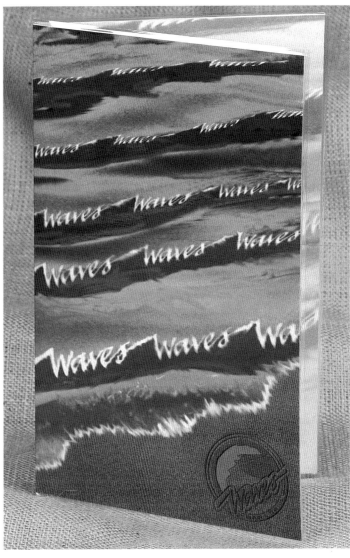

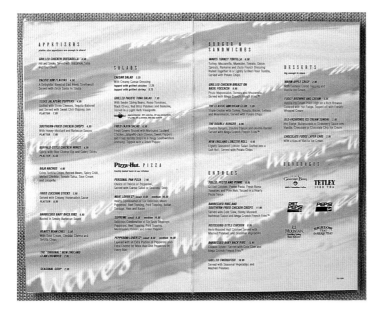

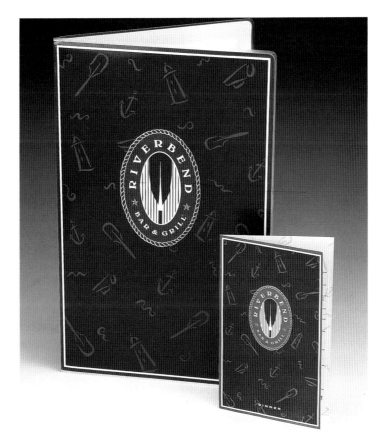

Restaurant
Riverbend Bar & Grill
Client
Marriott Philadelphia Airport
Design Firm
Associates Design
Art Director
Chuck Polonsky
Designer/Illustrator
Shirley Bonk
Paper
Carolina Cover

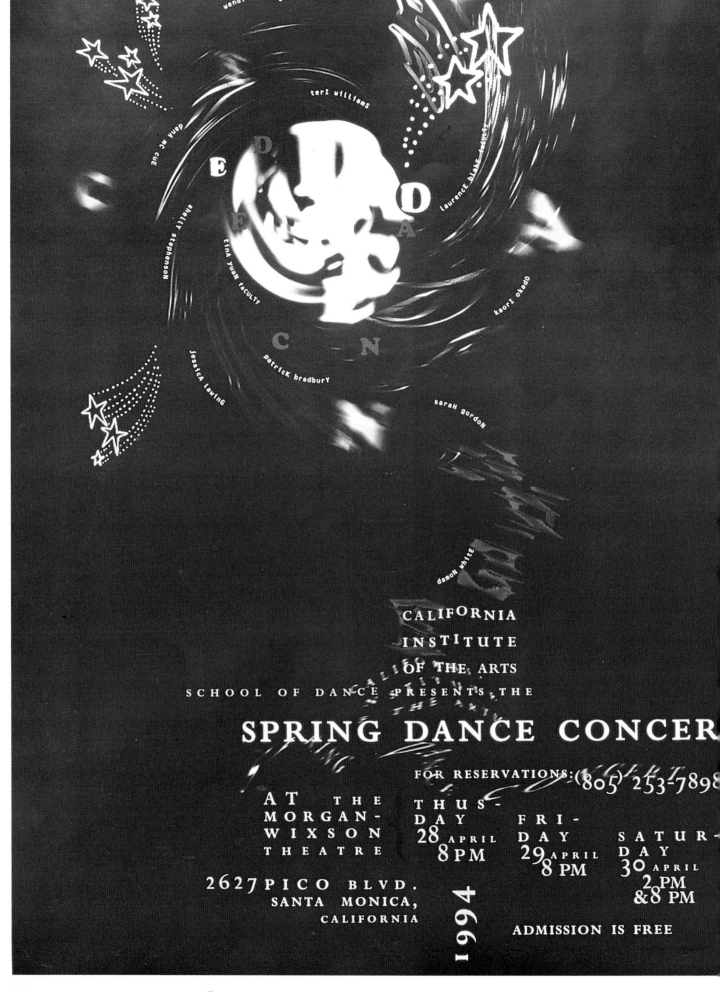

CALIFORNIA
INSTITUTE
OF THE ARTS
SCHOOL OF DANCE PRESENTS THE

SPRING DANCE CONCER

FOR RESERVATIONS: (805) 253-7898

AT THE THUS-
MORGAN- DAY FRI-
WIXSON 28 APRIL DAY SATUR-
THEATRE 8 PM 29 APRIL DAY
 8 PM 30 APRIL
2627 PICO BLVD. 2 PM
SANTA MONICA, &8 PM
CALIFORNIA 1994

 ADMISSION IS FREE

Design
Deborah Littlejohn and Shelley Stepp
Project
CalArts Spring Dance poster
Client
California Institute of the Arts Dance School
Tools
Adobe Photoshop, QuarkXPress, FreeHand on Macintosh

Fonts
Perpetua, Cooper Black

The unstructured typography opposes images of a traditional dance recital performed in the evening hours, transforming energy, movement, and structure into chaos.

1

PEACH PRODUCTIONS

T.J. Alexander
President

P.O. Box 7809
Marietta, Georgia 30065
404-421-9060
800-982-4251
FAX 404-421-8010

2

ARTIST

CHAEL PETRINGA

um St. • Arlington, MA O2174 • (617) 643-2732

ARTIST

MICHAEL PETRINGA

59 Varnum St. • Arlington, MA O2174 • (617) 643-2732

3

Maggie Marting
Midwife
3530 Burke Ave. N.
Seattle, WA 98103
(206) 547-4588

4

100·DM

Anja Schindelwick

Gluckensteinweg 86
61350 Bad Homburg v.d.H.

Tel. 061 72 - 3 77 05

1 Design Firm
Sharp Designs
Designer
Stephanie Sharp
Client
Peach Productions
Home show production

2 Design Firm
Studio Petringa
Designer
Michael Petringa
Client
Self-promotion
Fine art and decorative art

3 Design Firm
Michael Courtney Design
Designer
Michael Courtney
Client
Maggie Marting
Midwife

4 Design Firm
Tandem Design
Designer
Caren Schindelwick
Client
Anja Schindelwick
Financial advising

Design Firm
Fresno Pacific College
Art Director/Designer/Photographer
John Lopes
Original Size
5 1/2" × 5 1/2" (14 cm × 14 cm)
Client
Alumni Relations
Purpose/Occasion
Phone-athon Announcement
Printing
2-color lithography

Composed in Adobe PageMaker, this postcard incorporates wrapped/fitted text with a photograph of a phone receiver. The designer scanned the receiver directly on the scanner bed.

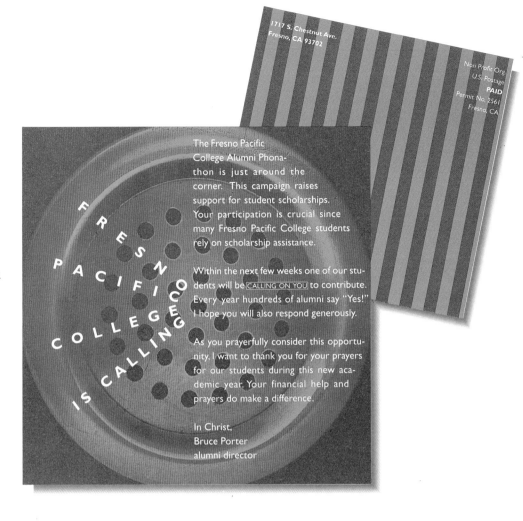

Design Firm
Cook and Shanosky Assoc. Inc.
Art Director/Designer
Roger Cook
Original Size
4" × 6" (10 cm × 15 cm)
Client
March of Dimes
Printing
2-color

This card, punched eighteen times for eighteen holes, is a reminder to attend a benefit golf outing. The designer produced it in QuarkXPress.

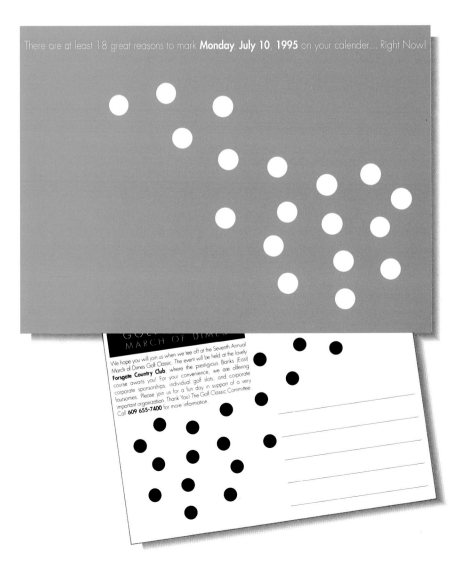

1

JUJU BEADS

2

C PICTURES

DONNA WOELFFER

2811 MCKINNEY NO. 204

DALLAS, TEXAS 75204

PHONE 214 855 0557

FAX 214 855 5068

3

46 Waltham Street Studio 307 Boston MA 02118
Phone: (617) 426-6479 Fax: (617) 426-5266

M

Susan Muldoon
Designer/Illustrator

1 Design Firm
Eat Design
Art Director
Patrice Eilts-Jobe
Designer s
Patrice Eilts-Jobe, Kevin Tracy
Illustrator
Kevin Tracy
Client
JuJu Beads
Bead collector and jeweler

2 Design Firm
Peterson & Company
Designer
Bryan L. Peterson
Client
C-Pictures
Photographer's representative

3 Design Firm
M Design
Designer
Susan Muldoon
Client
Self-promotion
Design studio

4/5 Design Firm
One & One Design Consultants Inc.
Designer
Dominick Sarcia
Client
Tom Black
Professional woodworking

4

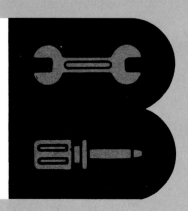

TOM BLACK

AUTHORIZED
FACTORY SERVICE
FOR DELTA MACHINERY

SERVICE ON OTHER
MAJOR BRANDS

13 DAPHNE COURT,
EDISON, N.J. 08820
1-908-668-1569

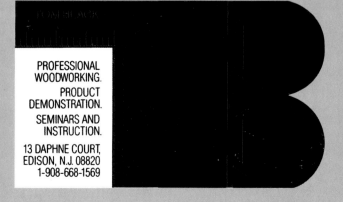

PROFESSIONAL
WOODWORKING.
PRODUCT
DEMONSTRATION.
SEMINARS AND
INSTRUCTION.

13 DAPHNE COURT,
EDISON, N.J. 08820
1-908-668-1569

Designer
K. Zickelman
Client/Store
Amen Wardy Home
Bag Manufacturer
Keenpac North America Ltd.
Distributor
Dixon Paper Co.

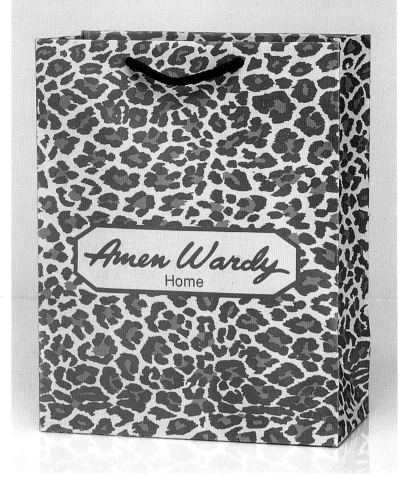

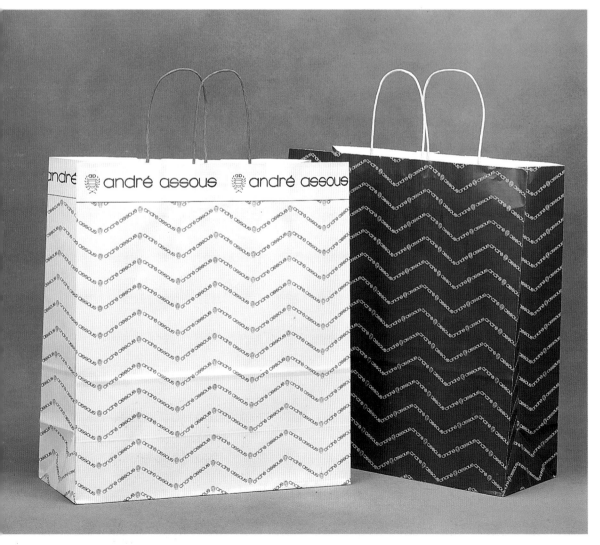

Design Firm
The AMC Group
Art Director
Andrew Kramer
Designer
Andrew Kramer
Client/Store
André Assous
Bag Manufacturer
North American Packaging Corp.
Paper/Printing
White coated kraft

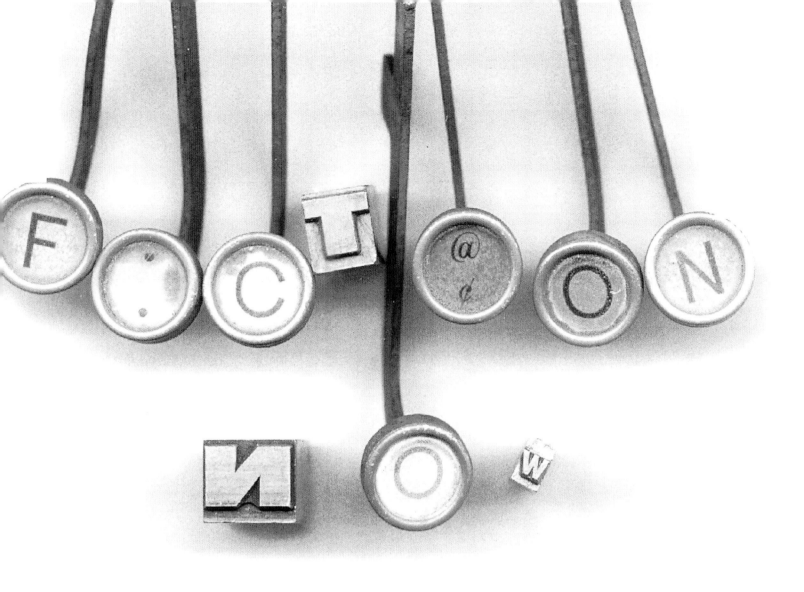

Design
Mary Evelyn McGough and Mike Hand for
Mike Salisbury Communications, Inc.
Project
Fiction Now logo and masthead
Client
Francis Ford Coppola/American Zoetrope
Tools
Adobe Photoshop on Macintosh
Font
Actual old typewriter keys, Franklin Gothic

Fiction Now is a new writers' journal—a forum for new writers of short fiction.
Old type keys were scanned and manipulated to read as a masthead.

Design
Paula Menchen for PJ Graphics
Project
Link
Tools
Adobe Illustrator on Macintosh
Font
Borzoi Reader

This is an unrealized logo design that was manipulated and altered in Illustrator.
The designer used Borzoi Reader and rescaled and redrew parts of the font.

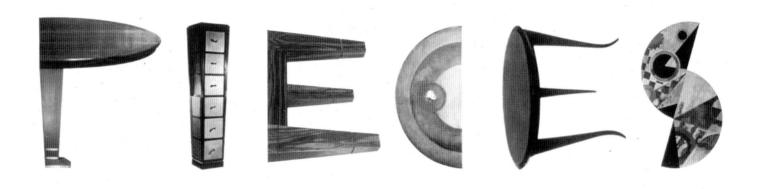

Design Firm
COY
Art Director
John Coy
Designers
John Coy, Rokha Srey
Production
Rokha Srey
Client
Pieces
Objective
To create an identity package to stimulate sales for a store dealing in custom,
limited-edition furniture

Innovation
This studio breaks with tradition by creating letters with furniture, such as a table leg for
the letter "P," and mixing them with a computer font. As a result, COY is able to translate
the classical elegance to the Getty Museum's Decorative Arts Collection into print.

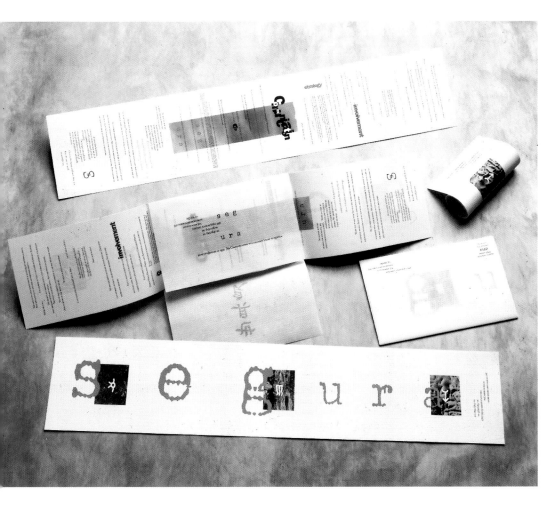

Design Firm
Segura Inc
Project
Communication
All Design
Carlos Segura
Photographer
Steve Nozicka

This self-promotional piece was printed in
two colors, green and black.

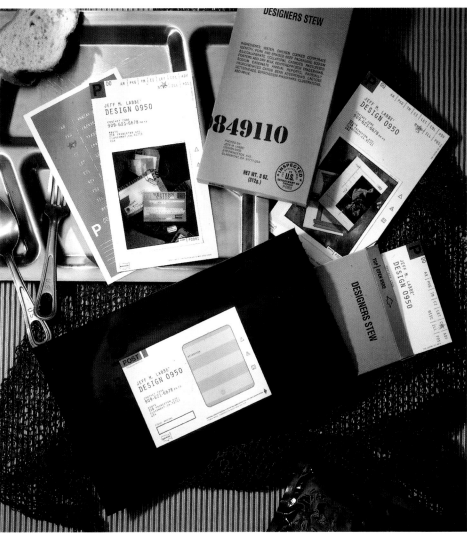

Design Firm
Jeff M. Labbé Design 0950
Project
Designers StewPromotion
Designer
Jeff M. Labbé
Art Director
Jeff M. Labbé
Writers
Finbar O'Keeffe, Jeff M. Labbé
Photographer
Kimball Hall

Each color piece of this military-themed project was
hand-tipped onto the support pieces which were printed
two over. The envelopes were purchased directly from
the US Army Government distributor. The cost was very
affordable compared to traditional means.

Design Firm
FORDESIGN
Designer
Frank Ford
Art Director
Frank Ford
Medical Fabricator
Michael Ford
Project
Mirage Furniture Signage

To reinforce the company's metal furniture fabrication, designers used a large sheet of .75-inch aluminum, found in a scrap yard, for this design. The logo was tiled out to two feet on a laser writer, making the template for carving the metal.

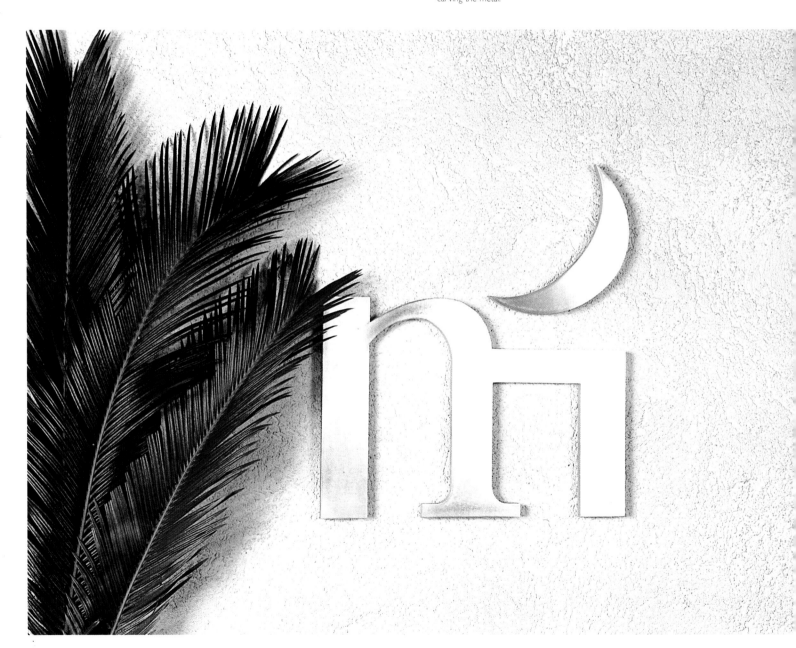

Design Firm
Letvin Design
All Design
Carolyn Letvin
Client
Kennedy & Company
Purpose or Occasion
National Wheelchair Championships
Number of Colors
Three

The original purpose of the shirt was fund-raising, but it was so well received that it was used as the official event T-shirt as well.

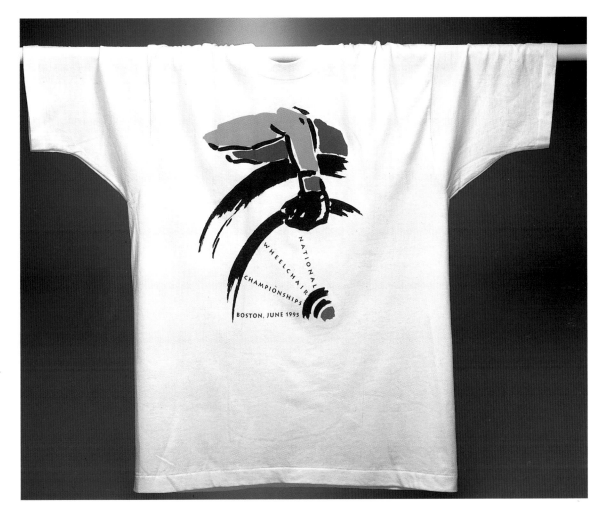

Design Firm
KCPQ Kelly Television
Art Director
Amy Garcia
Designer/Illustrator
Cory Brown
Client
MDA
Purpose or Occasion
VIP Day Camp Waskowitz
Number of Colors
Five

The idea behind this T-shirt design was to create an inspirational image for people with MDA. The designer chose the image elements, colors, and font style to appeal to children.

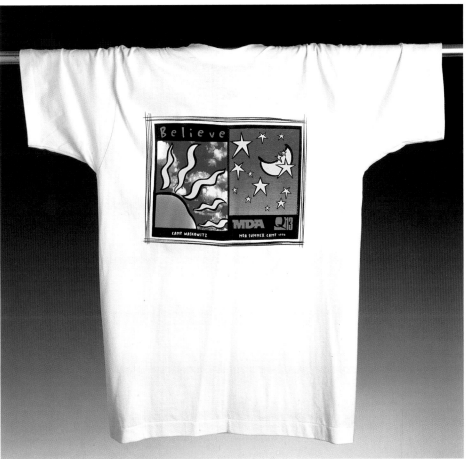

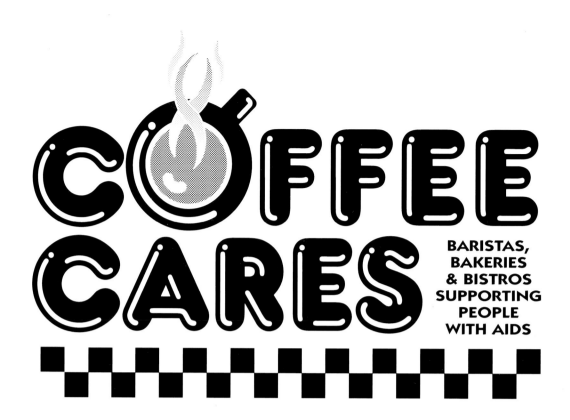

COFFEE CARES

BARISTAS, BAKERIES & BISTROS SUPPORTING PEOPLE WITH AIDS

Restaurant
Coffee Cares
Client
Our House of Portland
Design Firm
Jeff Fisher Design
All Design
Jeff Fisher

This image was created in Macromedia FreeHand.

Restaurant
Cafes Canal Place
Client
Canal Place
Design Firm
Hornall Anderson
Design Works, Inc.
Art Director/Designer
Jack Anderson
Calligrapher
Bruce Hale

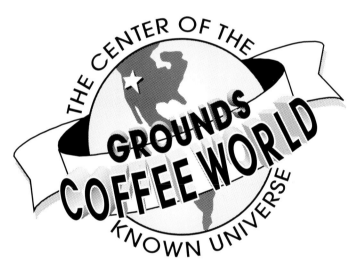

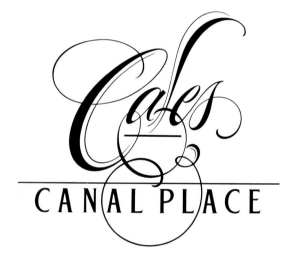

Restaurant/Client
Grounds Coffee World
Design Firm
Jeff Fisher Design
All Design
Jeff Fisher

This project was created in Macromedia FreeHand, with Ray Dream addDepth used for three-dimensional effect.

Restaurant
Last Drop Coffee House
Client
David Sokolow, Philip Cohen
Design Firm
Shelley Danysh Studio
All Design
Shelley Danysh

This entire logo
was hand-rendered.

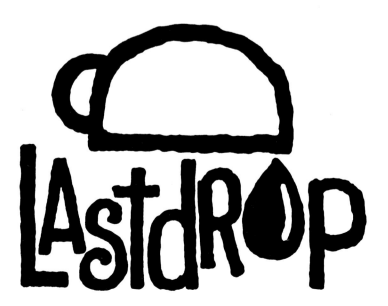

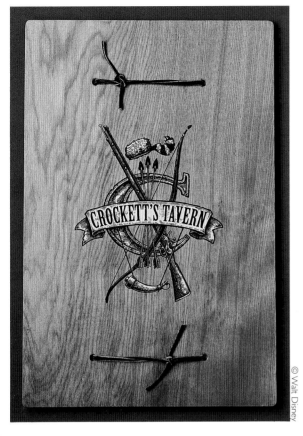

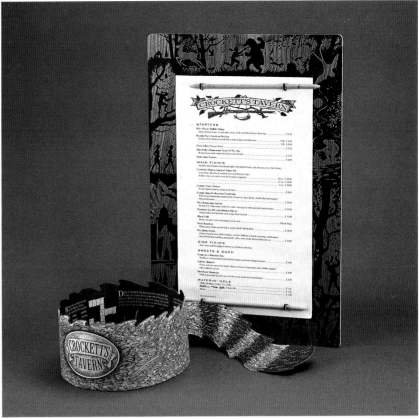

Restaurant
Crockett's Tavern
Client
Disney's Fort Wilderness Resort
Design Firm
Disney Design Group
Art Directors
Jeff Morris, Renée Schneider
Designers
Thomas Scott, Michael Mohjer
Illustrator
Michael Mohjer
Paper/Printing
Crosspoint Genesis, one color; Menu board on Birchwood, 2-color screen print; Inserts are French Butcher, two-color

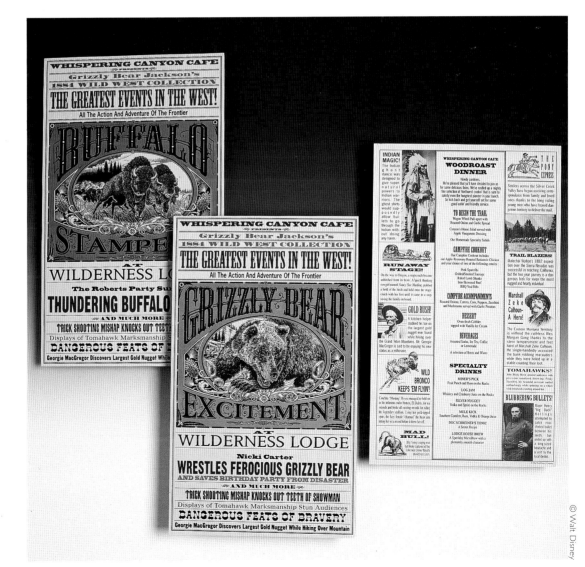

Restaurant
Whispering Canyon Cafe
Client
Disney's Wilderness Lodge
Design Firm
Disney Design Group
Art Director
Jeff Morris, Renée Schneider
Designer
Mimi Palladino
Illustrator
Michael Mohjer
Writer
Tony Fernandez
Paper/Printing
French Speckletone, 3-color

Design Firm
SullivanPerkins
Art Director/Designer
Brett Baridon
Client
Meltzer & Martin
Purpose or Occasion
Seventh Anniversary
Number of Colors
Three (front), One (back)

The T-shirt was created to celebrate Meltzer & Martin's seventh anniversary in business.

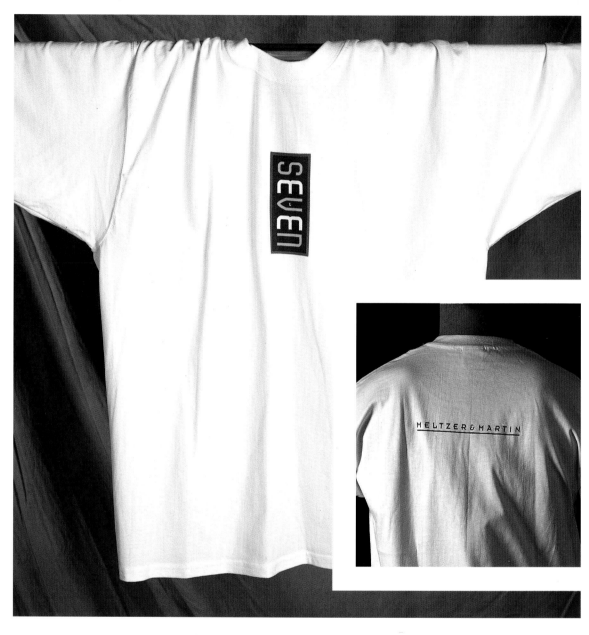

Design Firm
SUE NAN DESIGNS
All Design
Sue Nan Douglass
Client
A Stamp in the Hand/Kat Okamoto
Purpose or Occasion
The Original Rubber Stamp convention
Number of Colors
One

The intent was to design a wearable reminder of an enjoyable summer event. The suns were carved in a Nasco carving block and the letter forms in Staedtler-Mars erasers with Speedball lino cutters. The design was strong enough to warrant a one-color screening process.

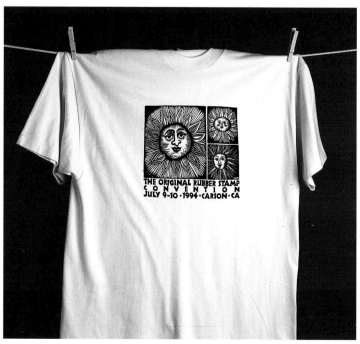

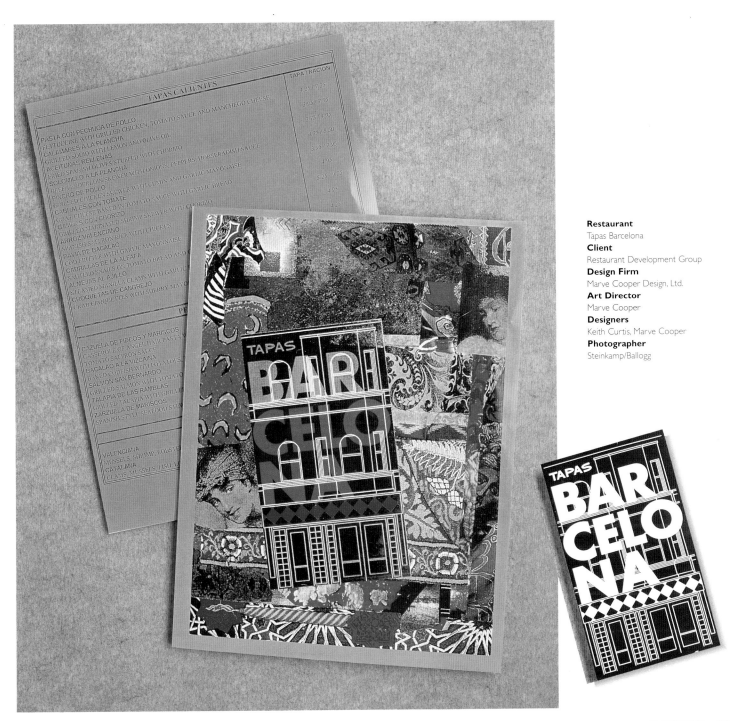

Restaurant
Tapas Barcelona
Client
Restaurant Development Group
Design Firm
Marve Cooper Design, Ltd.
Art Director
Marve Cooper
Designers
Keith Curtis, Marve Cooper
Photographer
Steinkamp/Ballogg

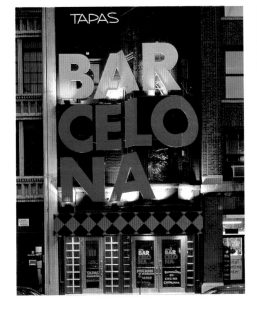

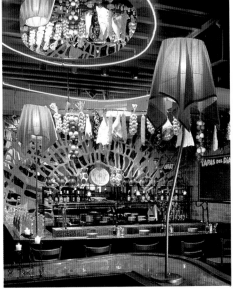

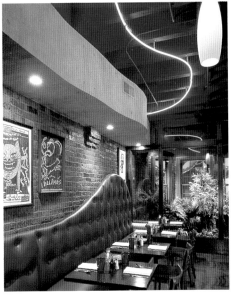

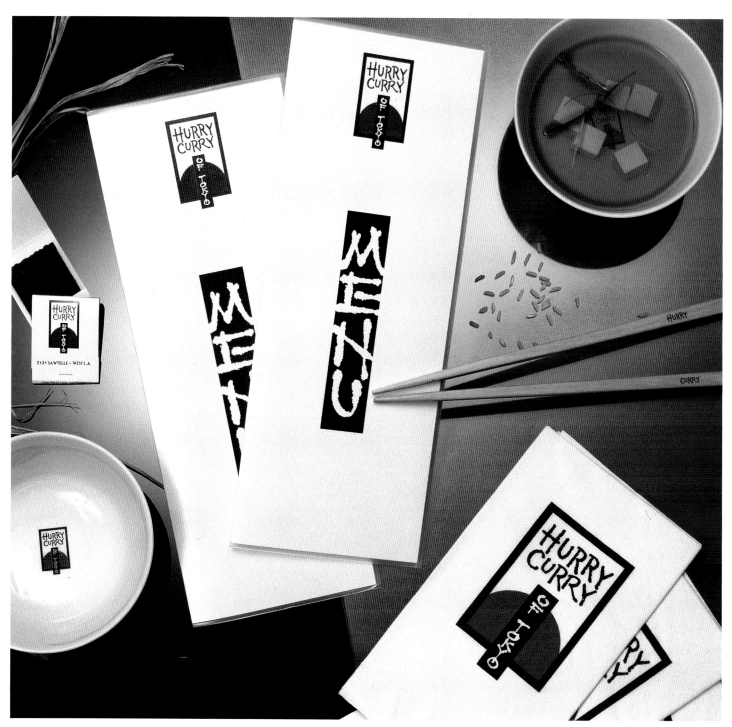

Restaurant
Hurry Curry
Client
Michael Bank, Randy La Ferr
Design Firm
Rusty Kay & Associates
Art Director
Rusty Kay
Designer
Randall Momii
Photographer
Bill VanScoy

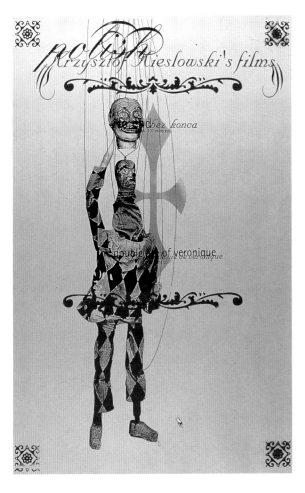

Design Firm
HMM Communications
All Design
Howard M. Montgomery
Client
Cranbrook Academy of Art
Purpose
Film series promotion
Size
11" x 17" (27.9 cm x 43.2 cm)

Designer used a combination of QuarkXPress, montage, and a small Xerox batch run to complete this poster project.

Design Firm
Margo Chase Design
All Design
Margo Chase
Photographers
Margo Chase, Merlin Rosenberg
Client
Graphic Communication Society, Oklahoma and Art Directors Club, Tulsa
Purpose
Lecture announcement
Size
16.25" x 21.5" (41.3 cm x 54.6 cm)

The designer used intentionally unsettling imagery from a variety of sources, juxtaposing it with big cut-up type to give the feeling of cage bars blocking the way.

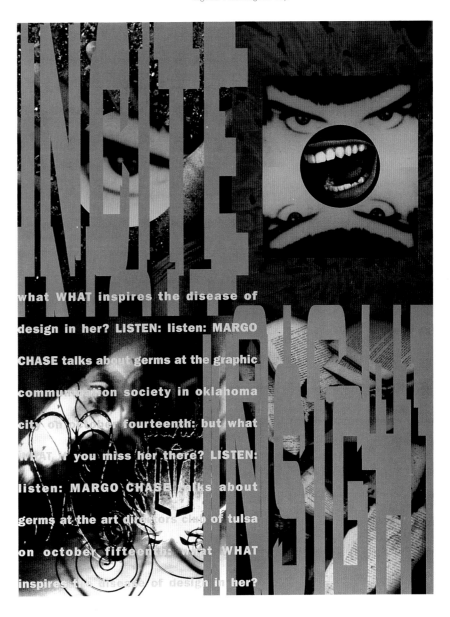

Design Firm
Watt, Roop & Co.
Art Director
Gregory Oznowich
Designers
Gregory Oznowich, Kurt Roscoe
Photographer
Martin Reuben Photography, Inc.
Client
The American Institute of Graphic Arts (AIGA),
Cleveland Charter
Purpose
Event Promotion
Size
20.75" × 21.75" (52.7 cm × 55.2 cm)

This poster was produced in PageMaker 5.0. No special techniques were used, however, special care had to be taken on press since all of the colors used were solid PMS colors trapping against one another.

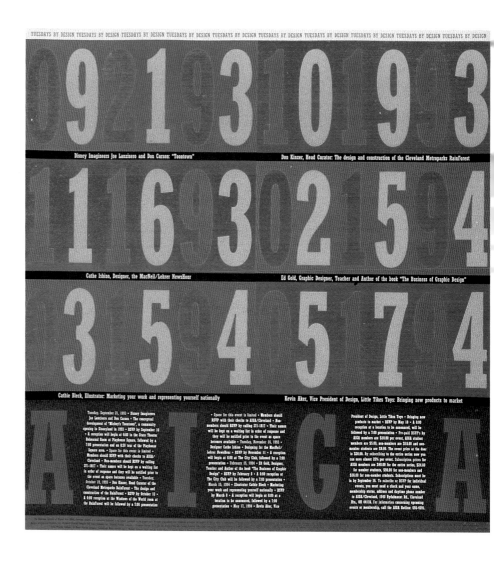

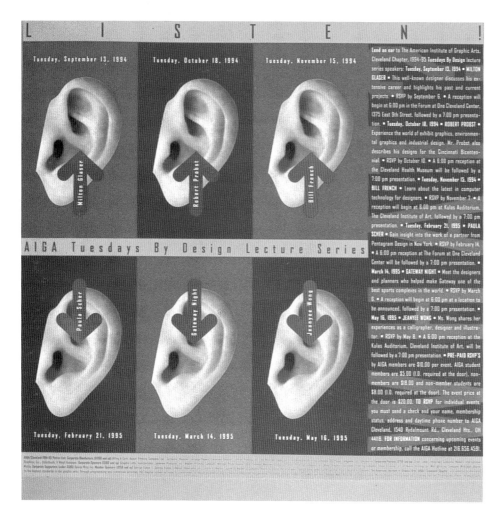

Design Firm
Watt, Roop & Co.
Art Director
Gregory Oznowich
Designers
Gregory Oznowich, Kurt Roscoe
Photographer
Martin Reuben Photography, Inc.
Client
The American Institute of Graphic Arts
(AIGA), Cleveland Charter
Purpose
Event Promotion
Size
22" × 21" (55.9 cm × 53.3 cm)

This poster was produced in PageMaker 5.0. The photos were supplied by the photographer as both high- and low-|resolution Adobe Photoshop documents. Designers placed the low-resolution EPS files into Aldus PageMaker for position only, and had the printer drop in the high-resolution versions later.

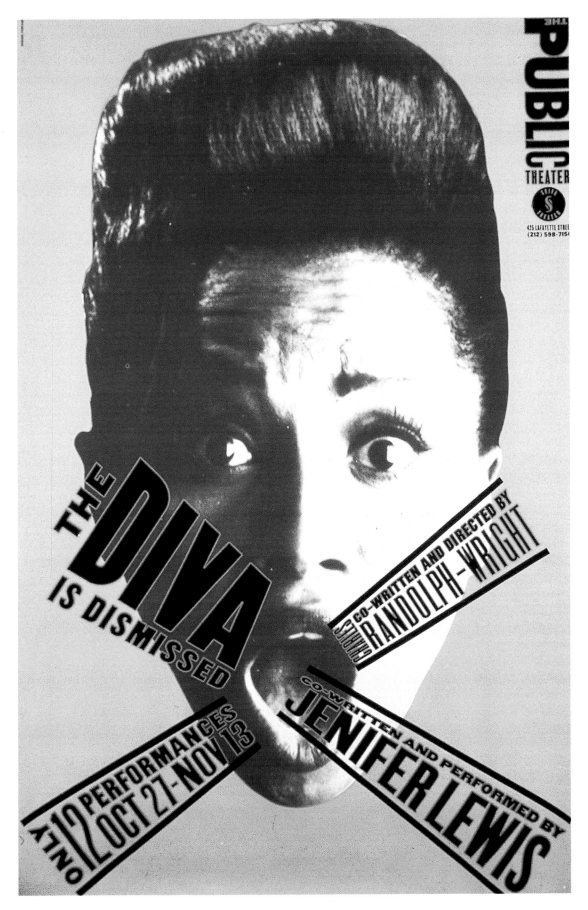

Design Firm
Pentagram Design
Project
Public Theater poster series
Client
Public Theater
Designers
Ron Louie, Lisa Mazur, and Paula Scher